IMAGES
of America
FRANKLIN LAKES

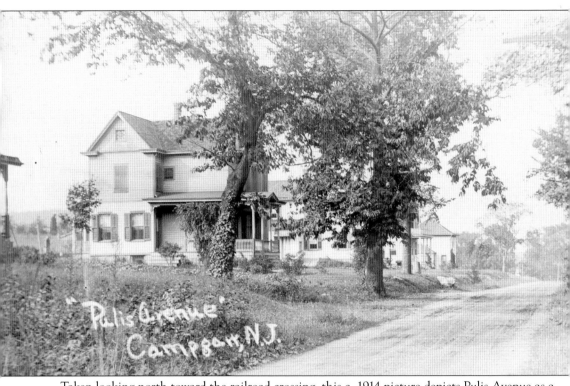

Taken looking north toward the railroad crossing, this c. 1914 picture depicts Pulis Avenue as a dirt road. (Courtesy Mabel Ann Watkins.)

ON THE COVER: A 1926 Seagrave fire truck leaves the Pulis Avenue firehouse en route to a Memorial Day parade. (Courtesy Franklin Lakes Library.)

IMAGES of America
FRANKLIN LAKES

Borough of Franklin Lakes and Colin Knight
Foreword by Mayor Frank Bivona

ARCADIA
PUBLISHING

Copyright © 2022 by Borough of Franklin Lakes and Colin Knight
ISBN 978-1-4671-0792-1

Published by Arcadia Publishing
Charleston, South Carolina

Printed in the United States of America

Library of Congress Control Number: 2022941310

For all general information, please contact Arcadia Publishing:
Telephone 843-853-2070
Fax 843-853-0044
E-mail sales@arcadiapublishing.com
For customer service and orders:
Toll-Free 1-888-313-2665

Visit us on the Internet at www.arcadiapublishing.com

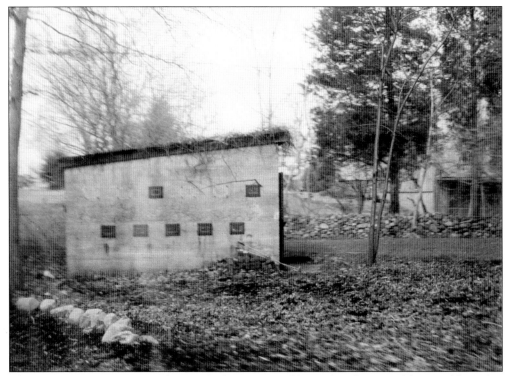

The Reaction Motors Test Facility was built in 1942 and located to the rear of the Franklin Lakes Airport. It was here is this small concrete shelter that important advancements were made in the field of Jet-Assisted Take Off (JATO) engines that proved essential for the Air Force during World War II. The facility was abandoned in 1944 after 16 months of operation. (Courtesy Jack Goudsward.)

CONTENTS

Foreword		6
Acknowledgments		7
Introduction		8
1.	Historic Homes	9
2.	Campgaw	21
3.	Crystal Lake	49
4.	Franklin Lake	53
5.	Farms to Suburbs	71
6.	Local Government	103
7.	First Responders	111
8.	Schools	119

FOREWORD

The Borough of Franklin Lakes was formed 100 years ago. We celebrate the borough's centennial anniversary by reflecting back with pride in our past and faith in our future! We are blessed with a rich history that is the foundation for the beautiful and vibrant community that we now enjoy. As we celebrate, it is important to reflect on our past and document it for future generations to come.

The enormous task of compiling old photographs and stories of our past for this book was led by Colin Knight, author and member of the Franklin Lakes Historical Society, and Dina Robinson, the borough's community director and centennial chair. Without their hard work and determination, this trove of Franklin Lakes history would not have been possible. I speak for all residents—past, present, and future—in offering my sincerest appreciation for their extraordinary efforts and those of their team members.

—Frank Bivona, mayor

ACKNOWLEDGMENTS

Though impossible to thank everyone involved with this project, there are several people that this book could not have been done without. Please know that any omissions are not intentional. So many have contributed, and their participation has made this book all the better. In no particular order, massive thanks go to Paulette Ramsey for getting me involved with the Franklin Lakes Historical Society back in 2011 and everything she has done for me ever since, Mabel Ann Watkins for graciously allowing me to go through her family scrapbooks and providing hours of enjoyable conversation, John Bockhorn and Jim Bohrer for sitting down and telling stories of growing up in town in the 1930s and 1940s, Susan Pulis for sharing family photographs and stories, Warren Storms for providing early photographs of Upper Campgaw and the Storms and Valentine families, Jack Goudsward for keeping meticulous records and researching so many facets of town, and Roger Ahl for always being there to talk and share his unrivaled memory of the Franklin Lakes Police Department. The Franklin Lakes Library has been an incredible resource, and director Kerri Wallace and local history librarians Samantha McCoy, Jackie Bunker-Lohrenz, and Jackie Vicari so kindly allowed me to dive into the local history collection. Community director Dina Robinson and deputy borough administrator Lynette Sidoti were of big help bringing this project to completion. I want to thank Mayor Frank Bivona and 2021 council president Tom Lambrix, the council liaison for this project, along with the rest of the council, for their support and allowing me to tell the story of the town we all call home. I am proud to call everyone, listed and not, friends and thank them again for their input, support, and guidance as we celebrate the 100th anniversary of Franklin Lakes.

I would also like to thank my parents, Margaret and Scott, and my sister, Ryan, for allowing me to be myself and endure untold hours over the years of conversation, patience, and being there to help me conceptualize how to tell the story of my hometown. I love you all so much.

—Colin Knight, 2022

INTRODUCTION

For the occasion of the centennial of the Borough of Franklin Lakes, the Franklin Lakes Historical Society was approached by the mayor and council as well as the centennial chair about putting together some sort of publication for the event. With the help of longtime society members and our collection at the Franklin Lakes Public Library, the pieces started to fall together. Time and time again, the question arose of how do we tell the story of our town? As the book began to take shape, the path became clear. The story of Franklin Lakes starts as bucolic farmland worked by Dutch, French Huguenots, and English settlers. Following the rapid expansion of suburbs in the post-war era, our town quickly became one of the premier suburbs of the New York City metropolitan area, while still managing to retain our historic fabric

Franklin Lakes, as we know it today, started over a dispute about schools. The four-room schoolhouse at Campgaw had been cut up into so many small rooms that, by the time another room was needed, there was nowhere to go but outwards! It was decided that a new school should be built with eight rooms to meet a growing population. At that time, Campgaw and nearby communities, including Franklin Lake, Crystal Lake, and Wyckoff, belonged to the larger Franklin Township. Residents in Wyckoff wanted no part in funding the construction of a school that served none of their youth, stalling the expansion efforts. Several concerned townspeople led by William V. Pulis petitioned the State of New Jersey to allow Campgaw, Franklin Lake, and Crystal Lake to form their own borough. Under an 1894 law, boroughs could be formed with the consent of enough voters, but the real caveat was that boroughs had the ability to establish their own boards of education. Campgaw residents could get their new school, and citizens of Franklin Lake and Crystal Lake would join the community and enjoy the benefits of a centralized school district. On March 11, 1922, the state would pass an act of legislature forming the Borough of Franklin Lakes, Franklin being an homage to Franklin Township, named after colonial-era governor of New Jersey William Franklin, and Lakes in recognition of the 21 bodies of water located in town.

At the beginning, agriculture was the main game in town; hay, livestock, dairy, chicken, and some berry farming was conducted for export to markets in Paterson and New York City. Water-powered mills ground grain, turned and sawed wood, and, additionally, ground apples to make cider during the fall. With the coming of the railroad in 1872, the next hot commodity in town was land. Wealthy merchants from the very towns local farms exported to started to purchase land to build sprawling estates. Gentlemen farmers carried on the agricultural tradition, but rather than take active part in the farming, they hired local men to be estate managers or hired hands, visiting on weekends and living here full time in the summer. If they had to be in the city for work, they could take the train from Campgaw or Crystal Lake and be at work in an hour's time.

The largest landowners in town immediately before the start of World War II were Edward C. May and John McKenzie. It is upon these estates that today's familiar suburban streets are laid out. Ed May is best known for establishing the Shadow Lake Swim Club and developing the northern part of town. Upon John McKenzie's passing, he left his land to the Archdiocese of Newark. His mill at Franklin Lake was to be run by Fred Bender and his family for the remainder of his life, and the archdiocese was more than content to leave things be while it tended to its business across the region. In the 1950s, that would change with J. Nevins McBride, who persuaded the archdiocese that the land was much more valuable as real estate than as managed woodlands and set up Urban Farms and the McBride Corporation to sell lots and build homes catered toward college-educated households earning a decent living. The center point of Urban Farms and its developments was the Indian Trail Club. The members-only club provided a lake for boating and swimming, tennis courts, and a clubhouse. The Urban Farms development brought a population

boom to town unlike anything that had been seen before, ushering in the transformation from agricultural to commuter suburb.

Franklin Lakes is a borough of change, yet there are remnants of the past if you know where to look. With 13 Dutch stone houses, we claim the highest amount of any town in Bergen County; our current middle school contains elements of the original 1931 school; and the first firehouse and borough hall has been repurposed as the board of education's building. It is the hope that this publication will foster a better understanding of our borough's history and inspire others to preserve our links to the past.

One

HISTORIC HOMES

Dutch settlers were among the earliest nonindigenous groups to call western Bergen County, including the area now known as Franklin Lakes, home. Well skilled in construction, they began to build homes out of rubble stone found locally. Sandstone is occasionally featured in some of these houses, but their origin is unknown, as no sandstone mining operations are noted in the area. Before the rapid development in the 21st century, Franklin Lakes had 16 stone houses, the most in Bergen County. Of the remaining stone houses, four are known to date to pre–Revolutionary War times. In the period after the Revolutionary War, frame dwellings became prominent. Local men harvested wood from Bear Swamp and the Ramapo Mountains, with one branch of the local Demarest family running a sawmill operation in Bear Swamp. A unique exception to this is the John Alyea house from 1826, which is built primarily of brick and is one of a few of the time period of this construction in the region.

It is not uncommon to find historic houses in town that have been significantly renovated from their original appearance. These additions reflect growing families and improving economic situations. Several distinct types of architecture outside of stone houses are present in town, including Greek Revival, Downingesque, Italianate, and Gothic Revival. Also important to architectural history is the arrival of gentlemen farms. Old estates were purchased by wealthy Patersonians and New Yorkers, and original farmhouses were converted to more stately residences or Colonial Revival–style houses were built, like the Atterbury-Brockhurst mansion.

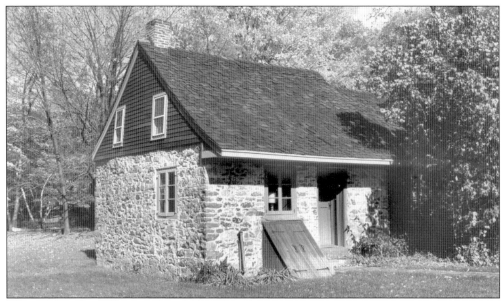

The Aaron Winters house is one of the oldest homes in Franklin Lakes, with construction dating back to 1710. The small cottage is a remnant of a much larger stone farmhouse, which supported a 300-acre farm that encompassed most of Shadow Lake. Oral tradition states that the Winters family hid their valuables in the 28-inch-thick walls of the larger portion of the house during the American Revolution, and subsequent generations tore the house apart to find these treasures, but no one is recorded as having found anything. (Courtesy Franklin Lakes Library.)

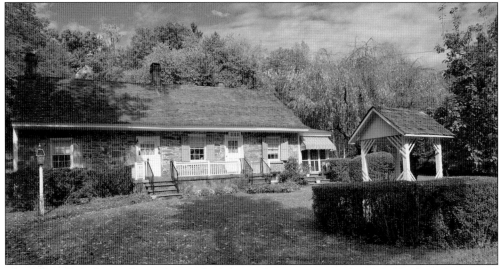

The Albert Pulis house, located on Pulis Avenue, first appears on the 1861 Hopkins-Corey map of Bergen County, but its construction dates it to the late 1700s. Minimal alterations to the original stone structure include a small eight-foot extension to the right of the structure. All other additions have been on the back of the house and cannot be immediately seen from the street. The Wyatt family lived here for a time, their daughter being actress Jane Wyatt, three-time Emmy winner for her work on *Father Knows Best*. Across Pulis Avenue on Loch Road is the former carriage house, which, for a time, was the Shadow Lake Clubhouse; it is now a private residence. (Photograph by Barry Glick.)

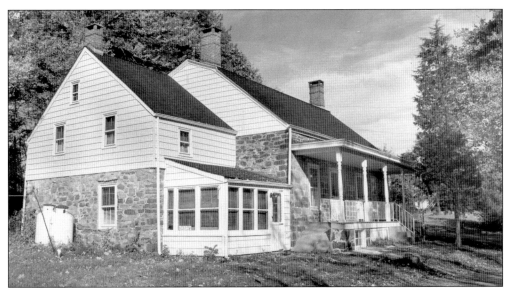

By the time the Van Houten house was demolished in 2001, six generations had called it home. Built around 1735, the Dutch sandstone dwelling was home to a very prominent and involved branch of the local Van Houten family. Members who lived here were involved with the founding and building of the 1806 Wyckoff Methodist Church, served on the local school board, and even acted as the director of the Wyckoff Savings and Loan Association. A small plot of land behind the farmhouse was deeded in 1830 to descendants to use as a "burying yard," with burials taking place as recent as 2004. A nearby crypt has been lost to time. (Courtesy Paulette Ramsey.)

Dating to the time of the American Revolution, the Daniel De Gray house stayed in the family until 1906, when it was sold to an architect who greatly expanded the original stone structure. An original c. 1785 Dutch barn is the last standing type in town and calls back to a time when the once 123-acre estate housed cows and chickens. (Photograph by Barry Glick.)

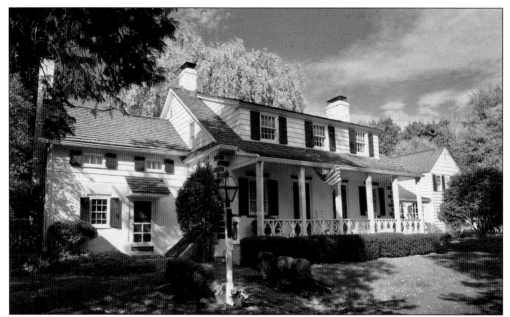

The Packer house is dated to 1789; however, like many of the original homes in the area, it most likely has portions that are older as it was greatly added on to during the time of the American Revolution. A deep fireplace in the original kitchen is typical of the time, and some sources date this small wing of the house to as early as 1730. The Packers were prominent farmers, and at one time, they operated farms up and down Ewing Avenue. (Photograph by Barry Glick.)

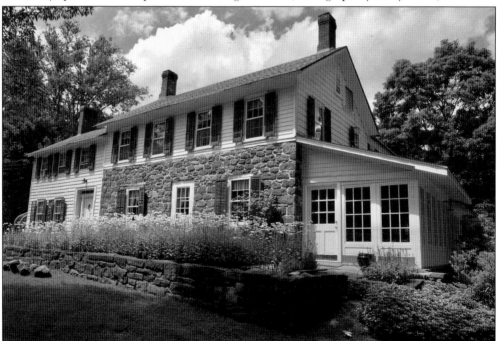

The Van Koert-Winters house is one of a few pre–Revolutionary War dwellings still left in Bergen County. Dating to 1710, the building is one of the few in town to be recorded on Robert Erskine's maps made up for Gen. George Washington. (Courtesy Borough of Franklin Lakes.)

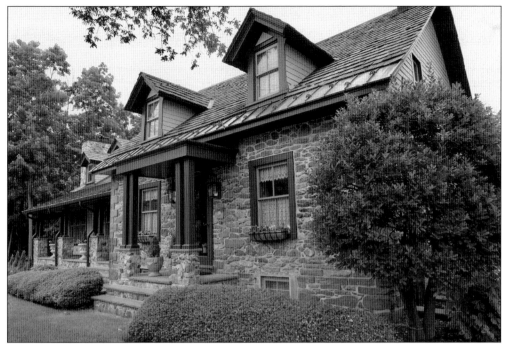

Located at the corner of Franklin Lake Road and Colonial Road, the Storms house, or Ackerman farmer's cottage, is believed to have been part of the original 222-acre farm associated with the Ackerman-Boyd house, located not far down the road heading toward Oakland. Despite Franklin Lake Road being heavily traveled by Robert Erskine, the dwelling is not on any of his maps, dating it to after the American Revolution. The house is said to have been a stop on a stagecoach line, and the owners of the house in the beginning of the 20th century removed a large bar from the cellar with coinage dating to the 1790s found beneath it, corroborating those stories. (Photograph by Barry Glick.)

Known as the Peter Winters-William Coerter house, this home first appears in records in 1833 when Susan Winters's birth was recorded here. A rear section with a vaulted ceiling and 18-inch-thick walls is thought to be the oldest part. A rear window is original to the construction period and still has leaded panes. (Courtesy Mabel Ann Watkins.)

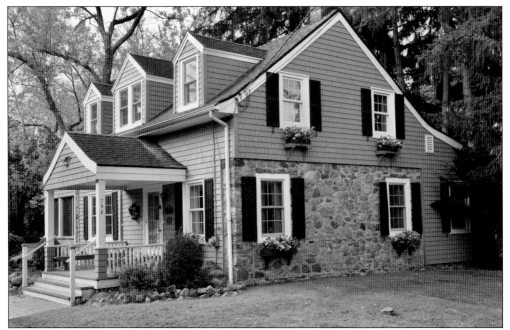

The house on the corner of High Mountain and Franklin Lake Roads has borne witness to all of the changes happening at the crossroads since it was built by Simeon Van Winkle in 1760. The Van Winkle family was among the first to settle the area and is said to have had four hogs stolen by the Continental army. Two of the four walls are made of stone while the rest are of frame construction, indicating, perhaps, that the structure burned and was partially rebuilt at one time. (Photograph by Barry Glick.)

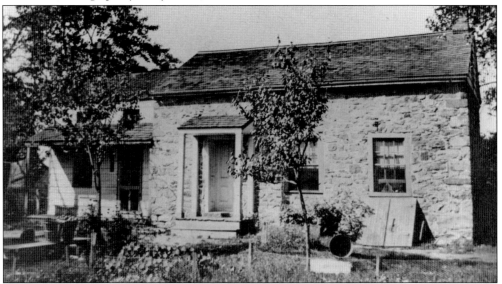

Shown in this 1907 photograph, the Pulisfelt-Courter house located near the Pulis Avenue railroad crossing is believed to have been built between 1790 and 1807. The tract of land the home sits on was purchased by Peter Pulisfelt in 1787 and is referred to as Lot No. 47 of the Ramapo Tract. The Fox family lived in this house for a time and operated a blacksmith shop across the street. (Courtesy Franklin Lakes Library.)

The William Ward house is believed to have been built in the 1760s, though certain architectural elements bear the mark of the Pompton Furnace, which was in operation from 1711 to 1729. As with other pre–Revolutionary War homes in town, there is a good chance that a smaller home was greatly expanded upon, retaining some original elements in the new construction. Later on, the barn was joined to the house to increase living space. (Photograph by Barry Glick.)

The J. Van Houten house on Summit Avenue is another example of the small farmhouses built at the turn of the 19th century. It is also the only house in town known to have been built in the Saltbox style, where the front of the house has a higher roof elevation than the rear. (Courtesy Paulette Ramsey.)

The Clapp-Cooke estate at 790 Ewing Avenue was built on land purchased from B. Ewing in 1906 and was heavily remodeled by the Cooke family in 1925. Built to resemble the Dutch Sandstone houses in the area, parts of the home may actually be an older dwelling associated with the Ewing estate. The last owner, Lucine Lorrimer, died at an early age from cancer and donated her 14-acre estate with carriage house to the New Jersey Audubon Society. Today, the house operates as the Lucine Lorrimer Nature Sanctuary. (Courtesy Colin Knight.)

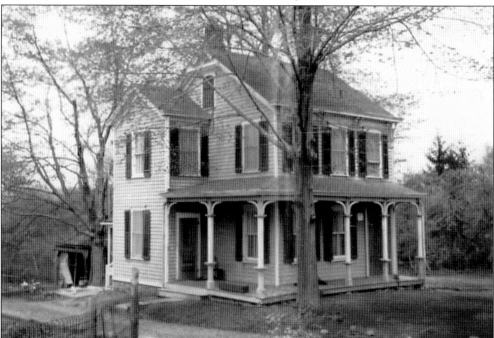

The Daniel Snyder house once stood on Ewing Avenue behind the Don Roerhrs Nursery. It is a typical frame farmhouse built sometime between 1876 and 1900. Walter Snyder, local builder responsible for construction of many homes in the area, grew up in this house. (Courtesy Jack Goudsward.)

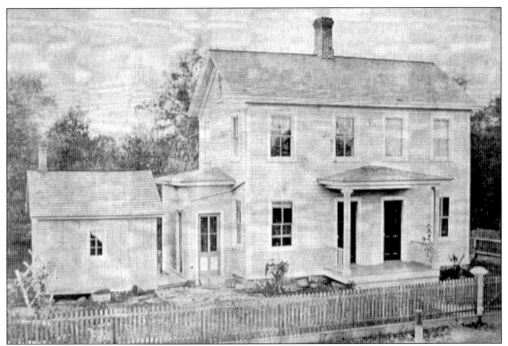

The Demarest house was built in 1890 and was occupied by members of the family until 1993. The first child born in the newly formed Borough of Franklin Lakes, John H. Payne Jr., was born in this house. (Courtesy John Payne.)

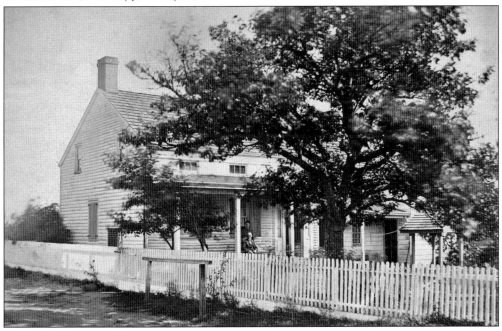

This undated photograph is of an early Pulis house that is thought to have been built around 1825 on land owned by Henry P. Pulisfelt. Two unnamed members of the Pulis family are on the porch. The present location of this home is where Vichiconti Way meets Pulis Avenue. (Courtesy Franklin Lakes Library.)

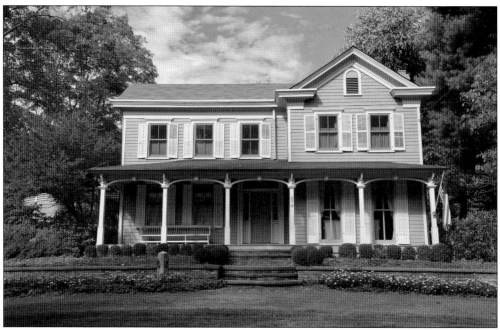

The H. Sturr house is one of two Sturr homes on Pulis Avenue that were built in the mid-19th century on land bequeathed in 1852 to the sons of Henry Sturr. The Sturr family came to the area in 1793 and settled on Old Mill Road. They dammed up the Ho-Ho-Kus Brook and operated a mill there. The dam can still be seen today on the Simms property. (Photograph by Barry Glick.)

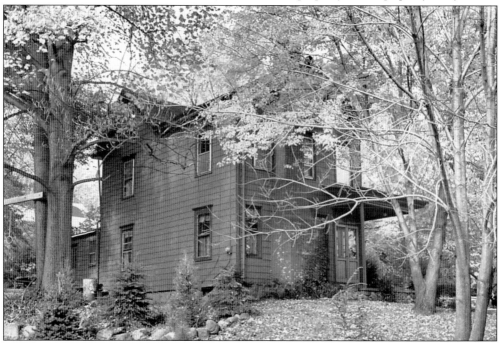

One of many homes on Pulis Avenue that was once owned by the Carlough family, this simple farmhouse that still stands is an example of many similar farmhouses that once dotted the landscape during the growth of farming operations in town. (Courtesy Paulette Ramsey.)

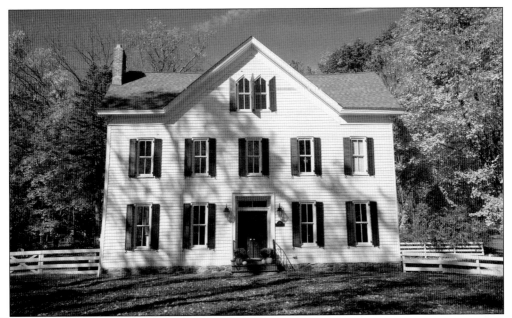

According to borough records, the William W. Pulis house was built in 1837 and remaining architectural and design details are typical of the era and support this. For its age, the house is rather large, reflecting the size and status of the Pulis family at the time. Empty for many years, it has recently been carefully restored. Older residents recall a large front porch with ornate details. (Photograph by Barry Glick.)

The Daniel Yeomans house sits behind the ruins of the cider mill along Franklin Lake Road. The mill was operated by the Yeomans family as early as the 1810s, when the home was located across Franklin Lake Road close to the Southside firehouse; by 1876, the home was moved to behind the mill. Dan Yeomans, born around 1798, worked the mill into his 90s. After Mackenzie purchased the land around Franklin Lake, the Fred Bender family took over as daily operators of the mill and moved into the Yeomans house. (Courtesy Mabel Ann Watkins.)

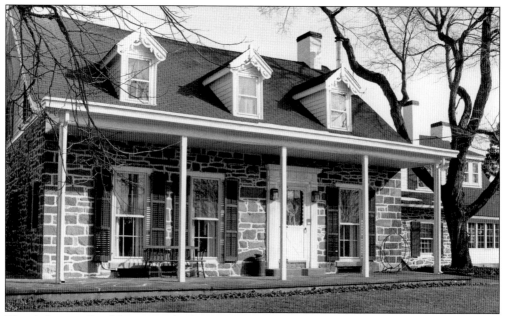

The Ackerman-Boyd house was built around 1785 on land purchased by the Ackerman family in 1727; they sold the home and surrounding property 90 years later. This is the earliest recorded Ackerman family living in the Crystal Lake and Oakland area. In 1841, Adam Boyd purchased the home and expanded it. Boyd was politically involved in Bergen County and served as sheriff, assemblyman, and, later, judge. (Courtesy McBride family.)

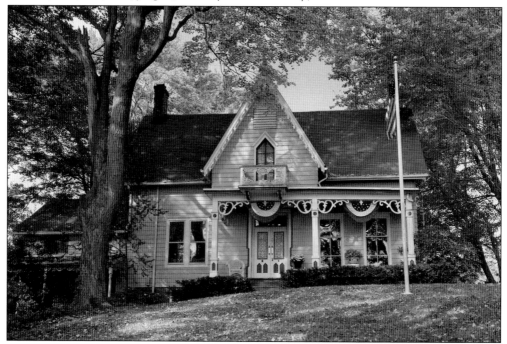

The Terhune-Post house dates to 1871; however, sections of the middle of the house may be older. In the 1940s, a farm stand was moved from elsewhere on the property and added to the structure. (Photograph by Barry Glick.)

Two

CAMPGAW

Though there is some disagreement as to where the name Campgaw came from, it first appears on a deed from 1700 as "Campque." After the Indigenous peoples, the early Dutch settlers farmed the land and manipulated waterways to take advantage of the hydropower. Families such as Winters, Ward, Ackerson, and Van Riper were among the earliest to settle in Campgaw and transform the landscape. Tired of traveling as far as Paterson and Suffern for Sunday worship, local Methodists built a church in 1856. It did not take long for the church to become the center of civic and social life. Before the coming of the New Jersey Midland Railroad in 1869, industry was primarily agricultural, with mills dotting the landscape. The iron horse transformed Campgaw, and the Pulis family quickly capitalized on the new reach afforded by it. By 1871, P.H. Pulis had founded the Pulis Mill, with a dedicated rail siding for the import of goods. The family business was run for five generations. The Pulis family was active in local business and politics, and descendant William V. Pulis was the primary force behind the incorporation of the Borough of Franklin Lakes and served as the first mayor. The Pulis Store was located adjacent to the Campgaw station, where P.H. Pulis was also the first station agent.

At the start of the 20th century, Campgaw was the focal point of the community and boasted a store, blacksmith, rail depot, post office, and church, which was more than sister communities Crystal Lake and Franklin Lakes could boast. The majority of the first council members lived in Campgaw, and many early improvements in town were centered there. The building of the 1924 firehouse and town hall cemented Campgaw as the hub of Franklin Lakes. When it came time to finally build the new eight-room schoolhouse, the obvious location was adjacent to the firehouse on the corner of Franklin and Pulis Avenues. Even today, DeKorte Drive, which is home to the borough hall, police station, and library, is located in what was once Campgaw.

By the 1950s, the name Campgaw began to be slowly phased out in official capacities. On November 1, 1951, the Campgaw Post Office became the Franklin Lakes Post Office to the dismay of old-timers who resented the loss of their unique locale. It would not be until the Campgaw station was torn down that the last vestige of the old hamlet would disappear from the landscape. The only callback now to the name is the Campgaw Mountain Reservation in neighboring Mahwah.

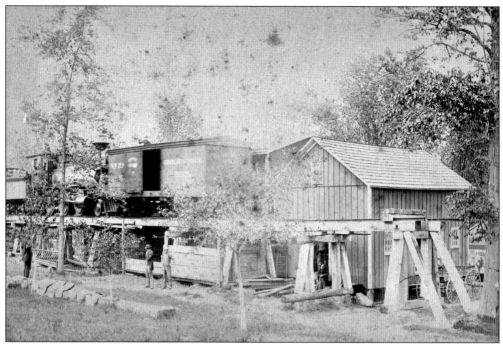

The earliest known photograph of the Pulis Mill shows the dedicated railroad siding, which would ultimately be covered up. Hoppers can be seen under the trestle to collect different goods that ranged from coal to feed. (Courtesy Susan Pulis.)

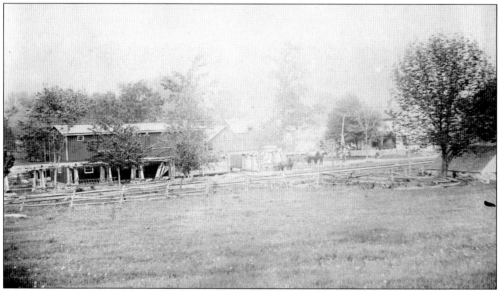

Another early shot of the Pulis Mill, taken from farther out, shows the uncovered railroad siding. Located in the center background is the Pulis livestock barn, and at center right are the Pulis house and general store. To the far right is the top of an icehouse or root cellar, both early forms of refrigeration relying on the cool ground to regulate temperature for storage of delicate goods. (Courtesy Susan Pulis.)

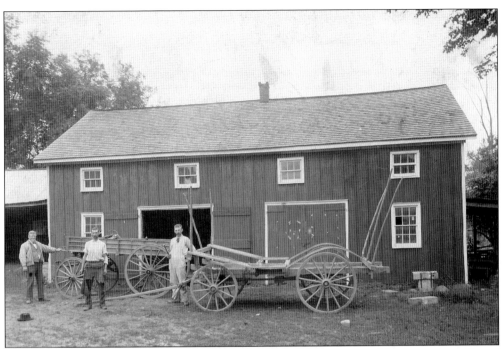

The blacksmith and wheelwright shop located on Pulis's property stood between the mill and the home at 430 Pulis Avenue. Samuel Pulis, second-generation owner of the Pulis Mill, stands at left with his arm outstretched. Next to him is John Fox, blacksmith and father of Charles Fox, early councilman. To the right is a young William V. Pulis, who would later be the first mayor of Franklin Lakes. (Courtesy Mabel Ann Watkins.)

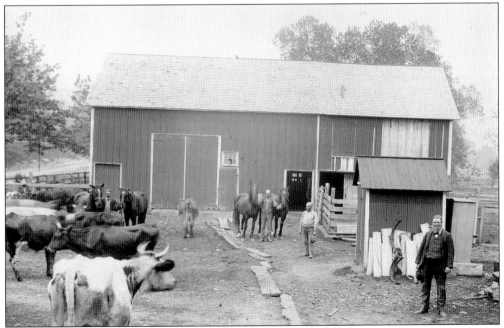

This barn was located behind the Peter H. Pulis house and general store. Peter H. Pulis is standing in the lower right. (Courtesy Susan Pulis.)

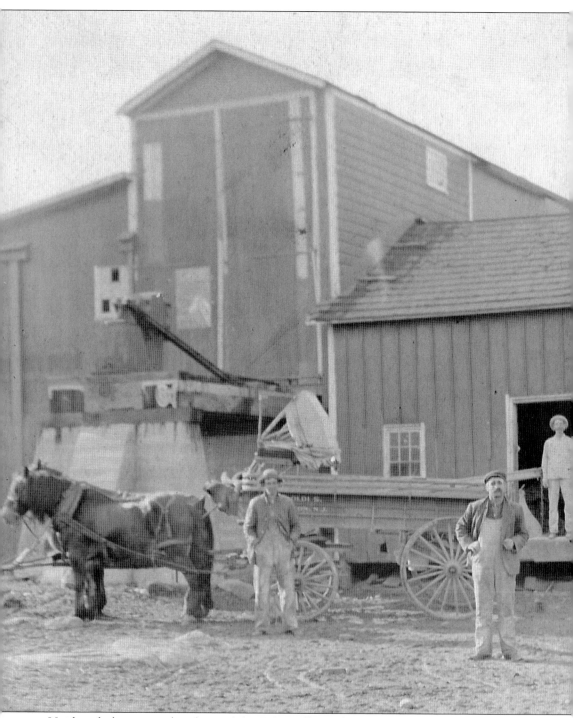
Unidentified men stand in front of the Pulis Mill. By this time, the railroad siding has been covered up, and the wooden supports for the track have been replaced with reinforced concrete.

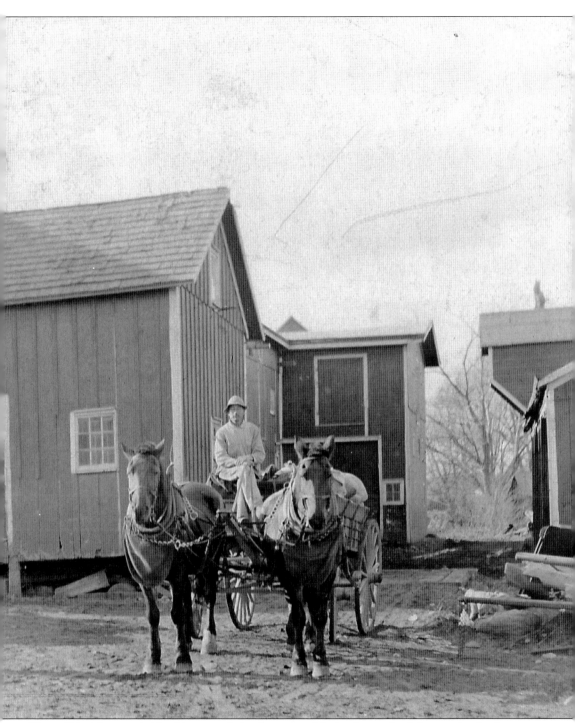
The mill has been considerably expanded to keep up with the demands of the growing business. (Courtesy Susan Pulis.)

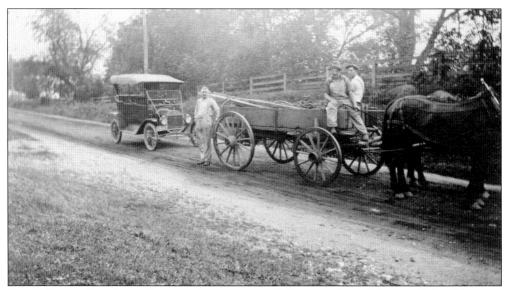

Sam Pulis stands in front of a horse-drawn wagon while out making deliveries. Behind him, an early automobile foreshadows the changes to come in town. Jake Valentine is steering the cart, and in front of them is the Pulis Mill. (Courtesy Jack Goudsward.)

This storage barn was located behind the Pulis Mill where Hans Auto Body stands today. In later life, the building served as the Yankee Workshop, a carpentry shop that specialized in cabinets. This barn was torn down in the late 1960s. (Courtesy Susan Pulis.)

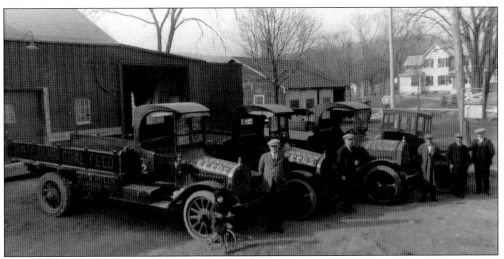

William Pulis (at left between first two trucks) stands in front of a modernized fleet of vehicles around 1925, and his grandson Herbert shows off his spiffy three-wheel bike. (Courtesy Susan Pulis.)

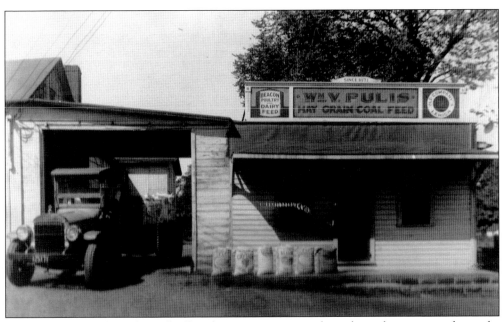

This 1930s shot of the Pulis Mill office shows a company truck on the scale getting ready to take a delivery. (Courtesy Pulis family.)

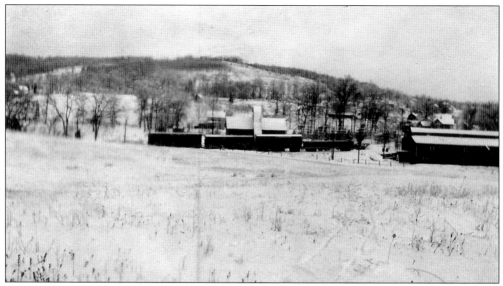

A coal train unloads at the private rail siding that serviced the Pulis Mill. The tall portion of the middle barn is a conveyor belt that would bring coal into the storage barn from the catch basin below the tracks. (Courtesy Pulis family.)

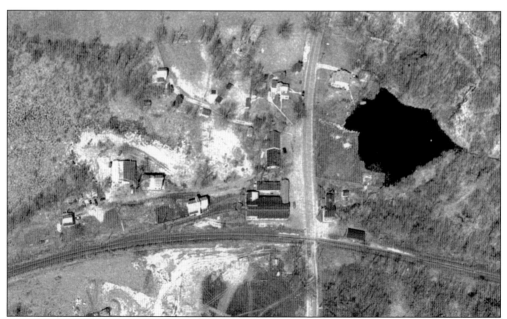

This 1957 aerial shows the Pulis Mill complex a year before it was sold. Several Pulis family houses can be seen in addition to the Campgaw Station located at the upper right of the railroad crossing. The coal barn and hopper, covered rail siding, mill office, post office, and all additional outbuildings can be seen. The mill and Pulis family were important pillars of early life in Campgaw, and the civic buildings and scope of industry shown here are a testament to that. (Courtesy McBride family.)

The c. 1900 Pulis family house still stands today at 430 Pulis Avenue with few alterations. On the right-hand side is a screened door, which is where the Campgaw Post Office was relocated to prior to 1907. (Courtesy Susan Pulis.)

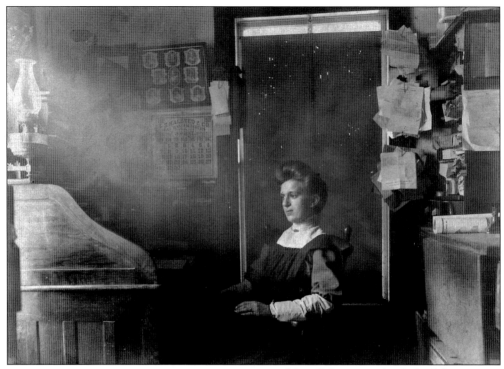

Myra Pulis sits at the desk of the Campgaw Post Office, which was attached to the Pulis family home at 430 Pulis Avenue. Papers adorn the walls in addition to a map of Bergen County, and a gas lamp can be seen on the far left. (Courtesy Susan Pulis.)

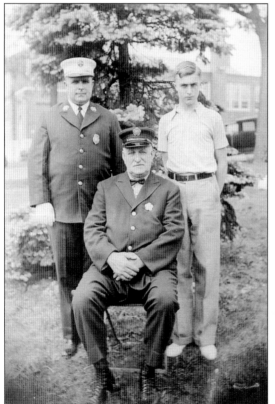

William Pulis (left) and Herbert Pulis (right) stand behind William V. Pulis in this 1931 photograph taken in front of the borough hall. Behind them is the newly opened Franklin Lakes School No. 1, today Franklin Avenue Middle School. (Courtesy Franklin Lakes Library.)

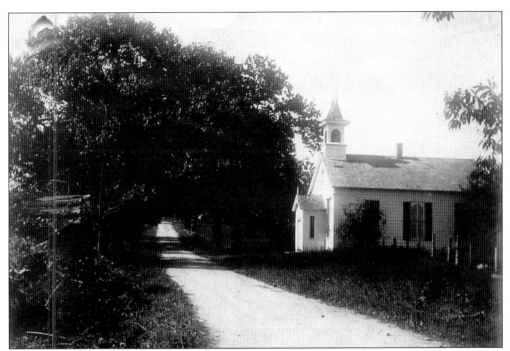

The 1855 Campgaw Methodist Church was built on land purchased from Henry Sturr. James W. and William Pulis are noted as chief builders with local townspeople assisting in sourcing logs and providing additional labor. (Courtesy Franklin Lakes United Methodist Church.)

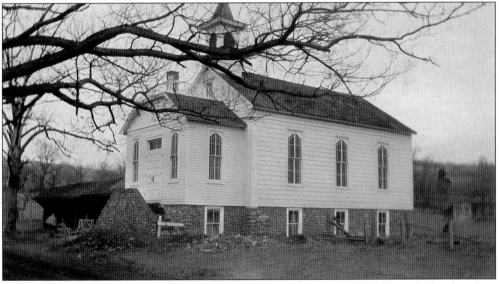

Under the leadership of Reverend Versteeg, a stone foundation was built beneath the church to provide a space for Sunday school and social purposes. Two years later, in 1917, William Pulis built an electric plant for his mill and offered five years of free electric power to the church if the church could find someone to wire it and provide lighting fixtures. In December 1919, while a quilting circle was being hosted in the basement, a fire was detected. The church burned in under an hour. Five years later, the Franklin Lakes Fire Department was formed. (Courtesy Franklin Lakes United Methodist Church.)

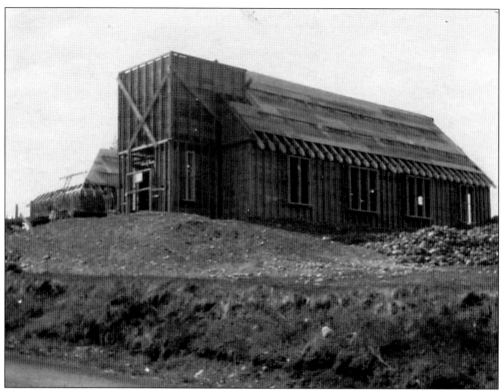
Captured during the building of the new Campgaw Methodist Church on Pulis Avenue, this picture shows the wooden framing that the stones were laid around. The stones can be seen in a massive pile to the right. (Courtesy Franklin Lakes United Methodist Church.)

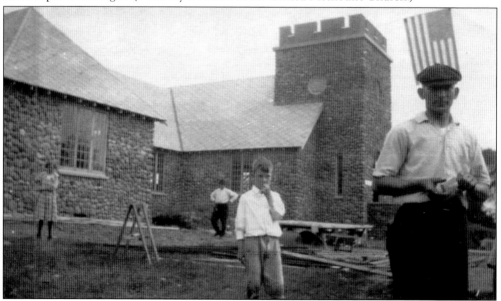
Here, people are standing in front of a nearly completed Methodist church in the summer of 1921. Windows have been installed, and preparations are being made for the opening services in September 1921. (Courtesy Franklin Lakes United Methodist Church.)

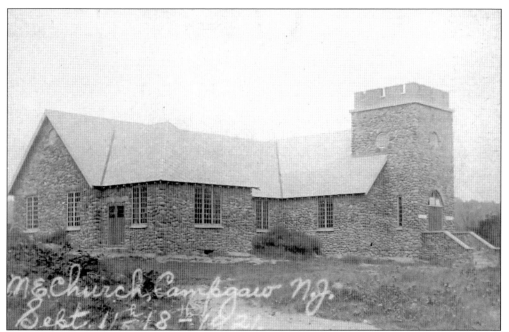

When the 1855 Campgaw Methodist Church burned in 1919, parishioners quickly sprung to action and constructed a new sanctuary up the hill on Pulis Avenue. Perhaps drawn to constructing a stone building to prevent another total loss, worshippers brought fieldstones from all over town to erect a new church. (Courtesy Franklin Lakes United Methodist Church.)

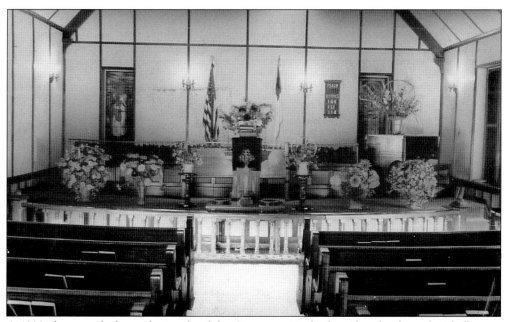

A 1938 photograph shows the inside of the Campgaw Methodist Church adorned with flowers. (Courtesy Franklin Lakes United Methodist Church.)

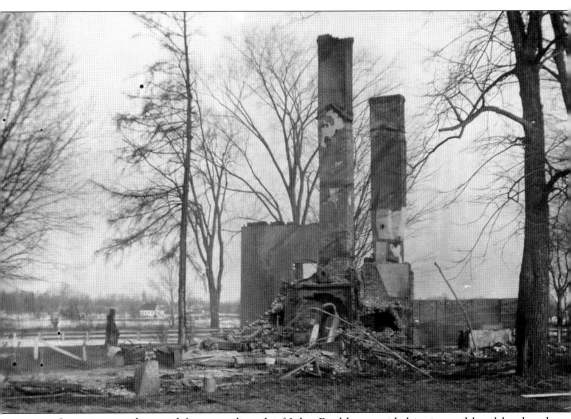

Longtime resident and former police chief John Bockhorn said this site and local landmark was called "Twin Chimneys." The ruins are of the Williams' house, which was located on Pulis Avenue and burned down before the 1920s. The Fardale church on Chapel Road in Mahwah can be seen in the distance. This penny postcard was made by Frances Ackerman Storms. (Courtesy Mabel Ann Watkins.)

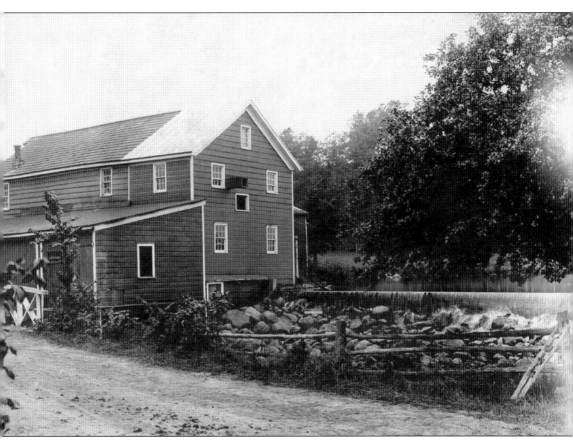

Taken in 1890, the Garret G. Ackerman gristmill stood on the border of Franklin Lakes and Mahwah and was operated by a submerged turbine wheel with a vertical shaft. The dirt road is the original alignment of Pulis Avenue and today is a dead end called Park Avenue. (Courtesy Warren Storms.)

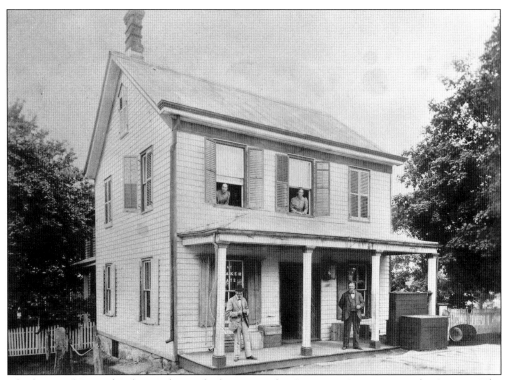

The home of Samuel Pulis was located adjacent to the Campgaw Station on Pulis Avenue. The first floor was the general store. Standing on the front porch in 1895 are, from left to right, Peter H. Pulis and Sam Pulis; in the windows on the second floor are Leah Valentine Pulis and Margaret Sturr. The building later became the E.D. Browne Grocery store and, in 1952, the first Franklin Lakes Library. (Courtesy Pulis family.)

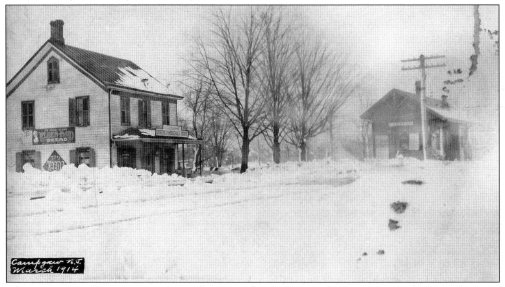

This snowy March 1914 image shows the Samuel Pulis house when it was rented to E.D. Browne, who ran a dry goods store there. The Campgaw Station is adorned in advertisements and waits for the next passenger train to arrive. (Courtesy Susan Pulis.)

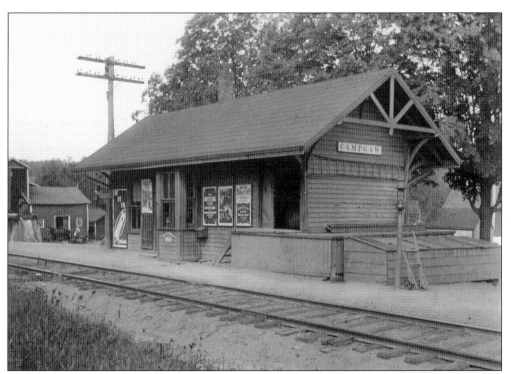

The Campgaw Station was built around 1872 for the New Jersey Midland Railroad. Located at the highest elevation on the line, a passing siding allowed for a "helper locomotive" to dismount after pushing heavy trains up from Oakland. (Courtesy the collection of Colin Knight.)

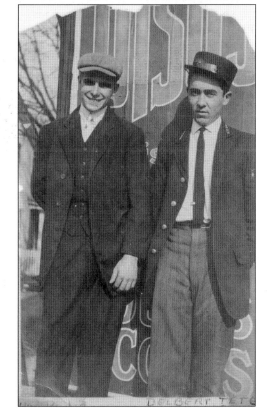

William V. Pulis and Campgaw Station agent Delbert Teter stand in front of an advertisement affixed to the station. Teter has a New York, Susquehanna & Western jacket with embroidered lapels and a cap on. (Courtesy Susan Pulis.)

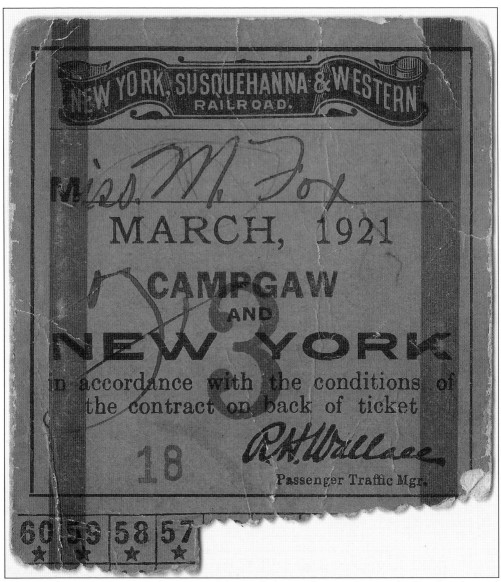

This March 1921 commuter ticket was issued to Mabel Fox. She grew up on a chicken farm located between the Campgaw and Crystal Lake Stations. (Courtesy Mabel Ann Watkins.)

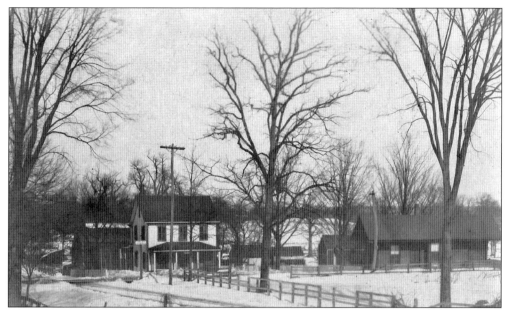

The Peter H. Pulis store is located at center left in this postcard from the early 1900s. Several outbuildings owned by the Pulis family can be seen in the background. At center right is the c. 1872 Campgaw Station. (Courtesy Susan Pulis.)

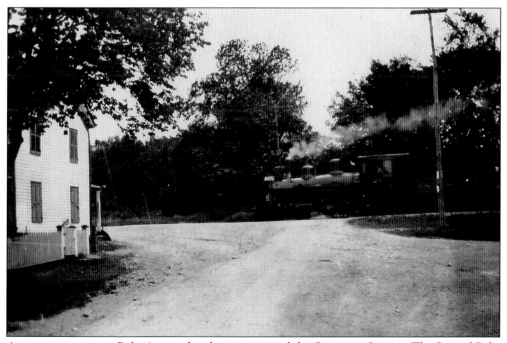

A steam train crosses Pulis Avenue heading east toward the Campgaw Station. The Samuel Pulis house and store can be seen at left. (Courtesy Susan Pulis.)

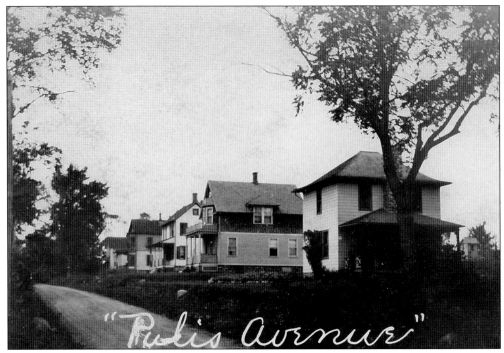

A different view of Pulis Avenue shows the original homes in the Campgaw area. Many of these homes still stand, though modified. The Kiempe Atema house in the foreground was torn down in 1967 to make way for the addition to the 1921 Methodist church. The white house in the middle was used as the church parsonage until the current one was built in 1957. (Courtesy Susan Pulis.)

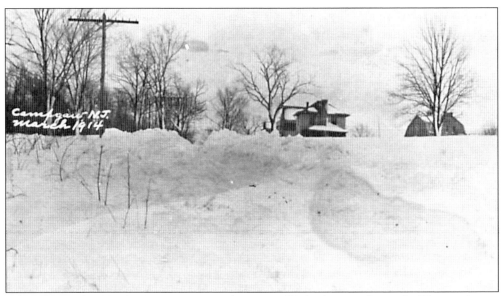

Taken during the March 1914 snowstorm, this view of Pulis Avenue shows the Kiempe Atema house and the top floor of the Campgaw School at center right. (Courtesy Susan Pulis.)

Anna (left) and Ethel (right) Ewing pose in their Sunday finest outside of their house on Pulis Avenue. (Courtesy Mabel Ann Watkins.)

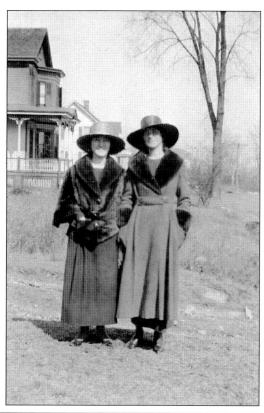

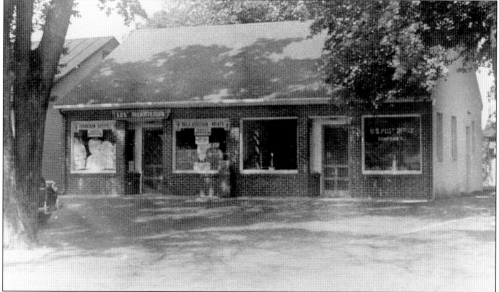

Changing attitudes about the location of post offices in private homes spurred the erection of a building on the Pulis property that would house the new post office with an additional storefront. The Campgaw Post Office would move here in May 1949, enjoying more space to accommodate a growing population. Next door was the popular Les's Delicatessen, which ran until 1973. (Courtesy Mabel Ann Watkins.)

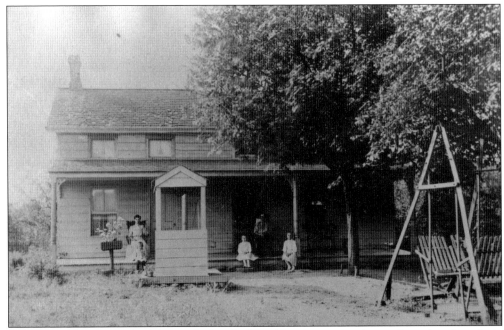

Charles Fox purchased the farm on the bend of Franklin Avenue bordering the railroad tracks in 1902 and operated a large-scale chicken farm that, at one point, accommodated 10,000 birds. In addition to being a founding councilman in Franklin Lakes, Fox also served as a committeeman in Franklin Township from 1909 to 1912. Pictured are, from left to right, Estella (Voorhis), Charles J., Mabel, Charles, and Grace Fox. (Courtesy Mabel Ann Watkins.)

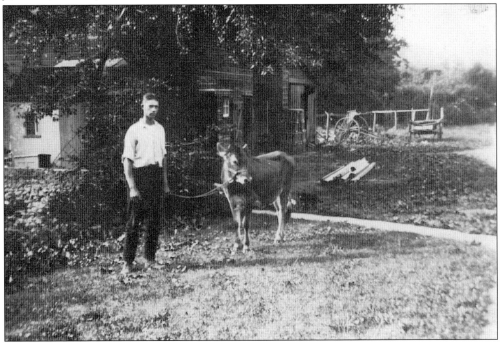

Charles J. Fox stands in front of a barn on the Fox homestead with a young calf in tow. (Courtesy Mabel Ann Watkins.)

Strawberry farming in Bergen County dates back to the early 1800s and was highly profitable and nationally recognized until the industry moved to South Jersey. Charles Fox Sr. experimented with growing strawberries, as seen in this rare photograph of the crop being harvested in town. Today, this scene is the parking lot for the Stop and Shop on Franklin Avenue. (Courtesy Mabel Ann Watkins.)

Grace Fox crouches on a large rock located on her father's property on Franklin Avenue. In the background is the Henry W. Pulis house, which still stands today on the corner of Franklin and Circle Avenues. (Courtesy Mabel Ann Watkins.)

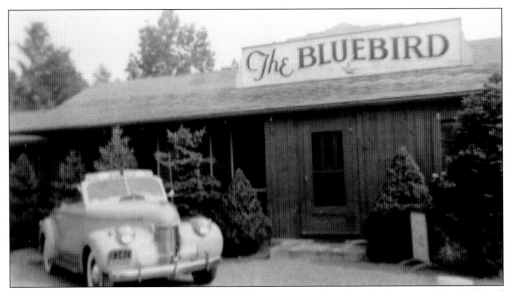

The Bluebird Inn and Tearoom was a formal dining room and kitchen. It first opened in 1935 and served customers until 1975, when the adjacent Colonial Wayside gift shop moved into the space. The establishment was a no-smoking and no-drinking affair. The main dining room, named the Hamilton Room, could seat up to 100 people. (Courtesy Susan Pulis.)

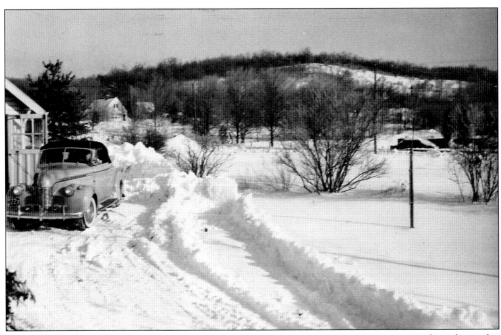

This 1940s view of the southern end of the Campgaw Mountain Range was taken from the backyard of 420 Pulis Avenue. At center right, the foundation of the 1915 Methodist church can be seen blanketed in snow. (Courtesy Susan Pulis.)

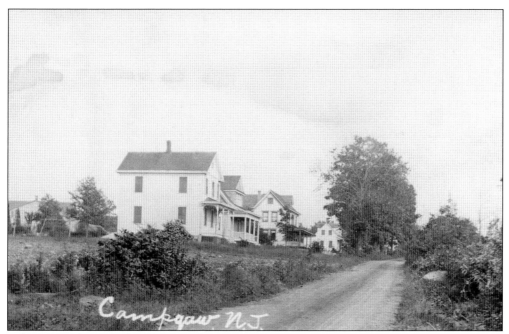

Taken around 1912 looking up Franklin Avenue heading toward Pulis Avenue, this photograph depicts the typical frame-style buildings of the era that can be seen lining the road. To the extreme left, the roof of the relatively new 1906 Campgaw School can be seen. (Courtesy Mabel Ann Watkins.)

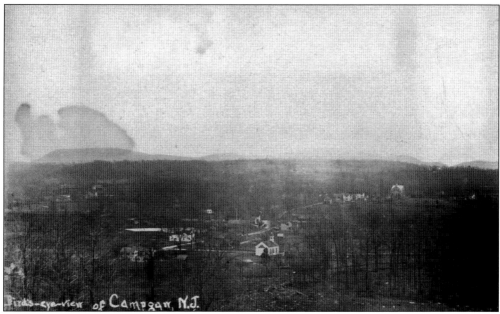

This rare bird's-eye view of Campgaw, taken pre-1915, shows the 1855 Methodist church on Circle Avenue, the Daniel Sturr house, the Pulis Mill, the Peter H. Pulis Store on the left of the railroad crossing, and the Campgaw School, where Franklin Avenue Middle School stands today. (Courtesy Susan Pulis.)

45

Pulis Pond was located on Circle Avenue past the Methodist church. This pond was filled in during the 1980s as part of the Interstate 287 extension project. (Courtesy Susan Pulis.)

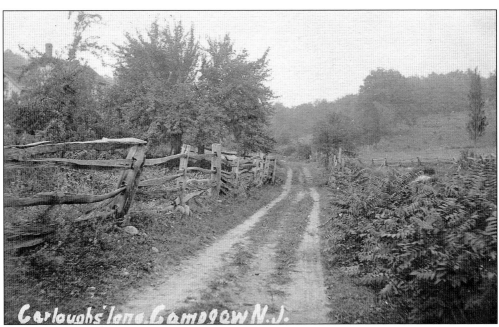

Believed to have been taken looking up the intersection of Mountain and Circle Avenues, Carlough's Lane was so-called due to the large presence of Carlough family members in the area and the c. 1840 John Carlough house, which is most likely the home seen off to the left. (Courtesy Susan Pulis.)

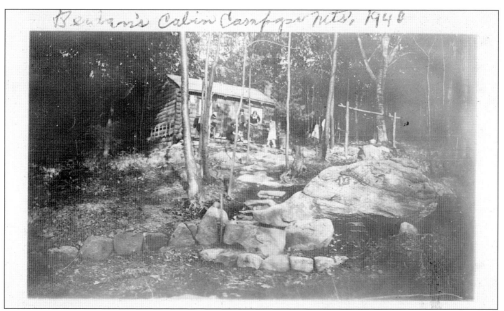

Farther up Mountain Avenue were several cabins belonging to both families in town and people in the area. The Charles Berdan Cabin was located at the top of a rock outcropping and was among the nicer ones. A notable feature was an attached mud- and straw-lined chimney braced with logs similar to early cabins that would have been built on the frontier. It is unknown when the cabins disappeared but probably occurred when Ed May sold his land to the US government for the creation of a Nike Missile Base as part of the defense of New York City in the 1950s. (Courtesy Mabel Ann Watkins.)

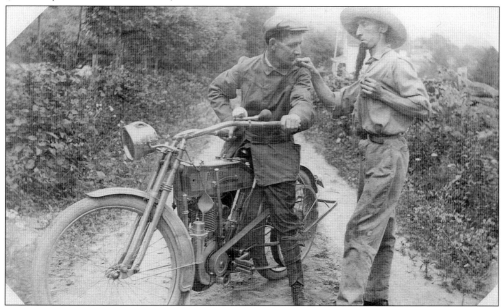

This c. 1910 photograph, taken on Colonial Road, shows Matthew Cosgrove seated on his early model Harley Davidson motorcycle while friend John Post shows off his marshal badge. The house in the background still stands today, and Colonial Road School was built on the farm property behind it. (Courtesy Franklin Lakes Library.)

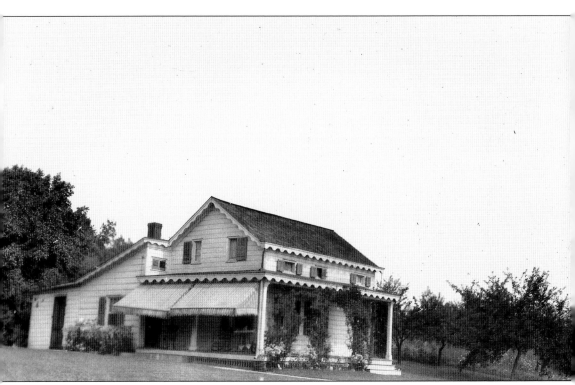

The Ed Carlough house was located on Pulis Avenue close to the intersection with Old Mill Road and is typical of the small-frame farmhouses associated with the agriculture history of early Franklin Lakes. (Courtesy Mabel Ann Watkins.)

Three

CRYSTAL LAKE

Crystal Lake was a small but active locale within Franklin Township. Straddling both Oakland and Franklin Lakes, the area was defined by Pond Brook, which flows out of Franklin Lake and ends at the Ramapo River. A public road followed the brook the entire length, and this road today is High Mountain Road. Among the earliest families to settle this area were the Ackermans and Demarests, who each operated mills along the brook for several generations. An 1830 road return (Bergen County E223) shows a sawmill on Pond Brook operated by John L. Ackerman. The Ackerman homestead was a stone house on the Oakland side of Pond Brook. Family history says that Johannes, an occupant, was at Valley Forge with General Washington. As many as five other mills operated in Crystal Lake, and the largest was a gristmill that was later converted to a silk mill by J.W. Ewing. According to historic accounts, the mill complex consisted of 50 rooms spread between seven buildings; this burned down sometime between 1905 and 1912. Millponds left behind after the industry faded made for popular swimming holes.

By 1872, the New Jersey Midland Railroad had finished work on the Franklin Lake Station and Depot, being on the direct road to Franklin Lake. By 1876, the station was renamed Crystal Lake, possibly an attempt to lure more travelers to the scenic area. A hotel was built adjacent to the station, complete with a barn to keep horses overnight and a bar to entertain visitors. Older residents in town recall only the station and inn, being the two landmarks that lasted the longest into the 20th century. The first war memorial in town was located across from the Crystal Lake Inn, dedicated to Zachariah Masker, the only resident in town to lose his life in World War I. Very little is left today of Crystal Lake as it was completely changed by the coming of Route 287, of which a portion follows the original High Mountain Road alignment between Colonial Road and Franklin Avenue in Oakland. Many of these pictures are published for the first time and offer a glimpse into a forgotten part of town.

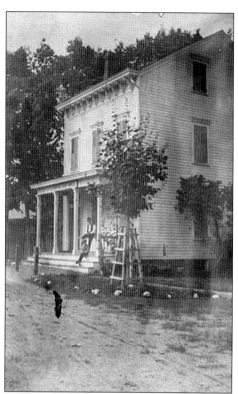

Built around 1875 by Paterson hotelier Michael Van Iderstine on land purchased from the Ackerman and Demarest families, the Crystal Lake Hotel served the nearby train depot and vacationers coming to the area to escape the busy life in Paterson and New York City. A bar on the first floor and a picnic grove to the rear proved a popular spot for day-trippers. (Courtesy Franklin Lakes Library.)

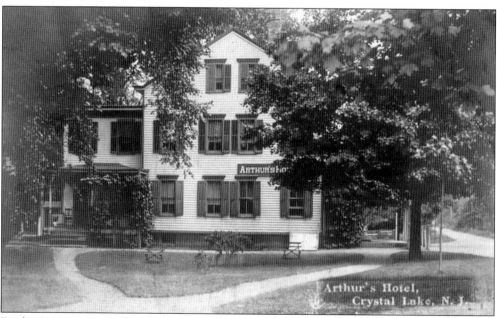

By the 1880s, Louis Arthur had married Van Iderstine's daughter and took over the operations of the hotel. Arthur renamed the business to Arthur's Hotel and ran it until selling it to the Hilbig family in 1916 The Arthurs' daughter Jennie served as postmistress for the Crystal Lake Post Office from 1903 to 1914. Louis Arthur was a distant relative of Pres. Chester A. Arthur. (Courtesy Franklin Lakes Library.)

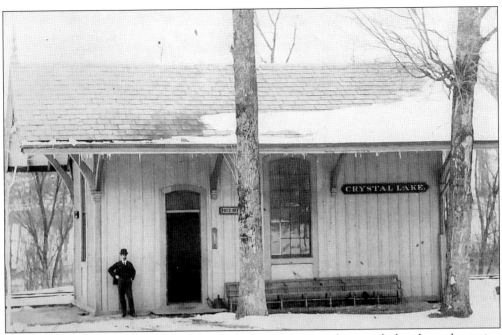

This winter scene of the Crystal Lake Station is the only known photograph that shows the station doubling as the post office. The Crystal Lake Post Office was established in 1894 and served the area until 1926. The Crystal Lake Post Office was the first in town, predating the Campgaw Post Office by four years. The man is unidentified. (Courtesy Franklin Lakes Library.)

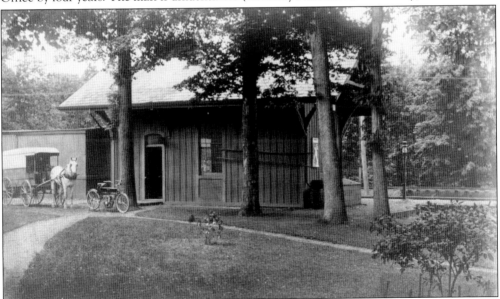

Here is a 1910s postcard of the Crystal Lake Station, erected by the New Jersey Midland Railroad around 1872. Beyond the lantern on the right, an elevated siding can be seen. Coal was dumped here for nearby mills located on Pond Brook that had been converted to steam power from hydro. A converted boxcar acts as storage for goods to be shipped to market in Paterson and beyond. A horse-drawn wagon juxtaposed with an early motorcycle highlights changes to come in this rural town. (Courtesy Franklin Lakes Library.)

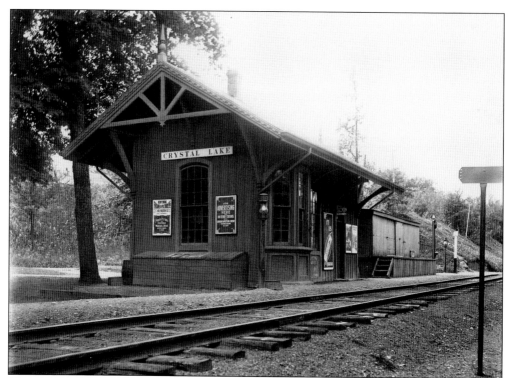

This 1910 file photograph from the New York, Susquehanna & Western shows the converted boxcar that was used as the depot building for freight coming and going from Crystal Lake. The station stopped having an agent in 1928 but still saw about five trains a day until 1966, when passenger service stopped altogether on the New York, Susquehanna & Western line as it was no longer being profitable for the company. The station was demolished in 1962. (Courtesy Colin Knight.)

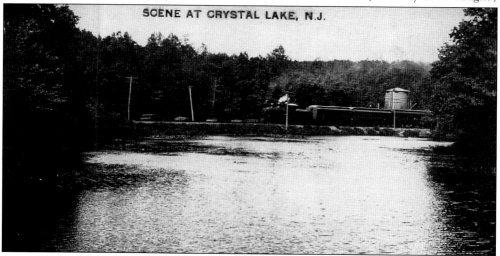

This 1914 postcard shows a New York, Susquehanna & Western passenger train heading east toward the Crystal Lake Station. Caille Lake is in the foreground and a spring-fed water tower can be seen in the background. Though much of this image has been covered up with the construction of Interstate 287, the support pillars for the water tower can still be found close to the railroad tracks. (Courtesy Colin Knight.)

Four

FRANKLIN LAKE

The area around the body of water that is Franklin Lake has long been the site of human habitation. Archeological explorations by Max Schrabisch were done in 1913, with sites discovered to the north and south of the lake, which the local Indigenous population are recorded as having named Michanagrape. Pond Brook was known as Katayack. Colonially, the lake was in East Jersey and was referred to in that time as Christian Pool. An early landholder with property bordering the lake was John Romine, who purchased his tract in 1724. Tax records from 1780 show familiar family names living around the "Big Pond," with Ackerman, Bogert, Van Houten, Romine, Storms, Van Winkle, and Stagg among 36 heads of house listed. Before 1818, a mill was built at the outlet of Franklin Lake into Pond Brook, serving a sawmill and gristmill in early years.

By 1876, the name Franklin Lake became commonplace. It was a popular bathing destination, which has carried into present times. John MacKenzie acquired 2,500 acres around Franklin Lake, or about 40 percent of town. His name appears next to 12 separate buildings on the 1912 Bromley map, including the cider mill. MacKenzie passed away in December 1943, and in 1948, his estate came into the hands of the Archdiocese of Newark.

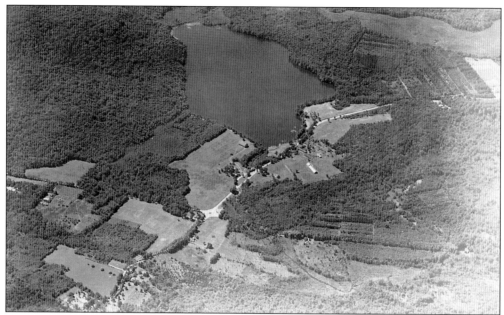

A 1955 aerial view of Franklin Lake and the traffic circle shows how undeveloped the area was. After the decline of the agricultural industry in town, fields became heavily wooded, with small patches left to accommodate livestock. At the beginning of the 20th century, most of the land shown here would have been owned by MacKenzie, with the majority of his operation focused around the mill on the northern shore of the lake. (Courtesy McBride family.)

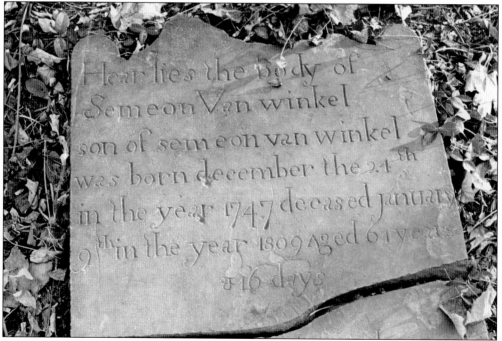

Simeon Van Winkle lived in the stone house at the northeastern corner of the High Mountain and Franklin Lake Roads intersection. An original settler of the Franklin Lake area, Van Winkle is buried at Crooked Pond Cemetery on the Franklin Lakes–Oakland border. (Courtesy Jim Longo.)

Locally known as the cider mill, this structure was a local landmark until it was destroyed by arson in 1972. Most likely taken from the porch of the Yeomans-Bender house, the rear of this structure is shown with Franklin Lake Road at center right. Across the street is the Josiah Yeomans house, which served as the offices for Urban Farms for a time. The covered shed structure is where the sawmill stood. (Courtesy McBride family.)

There is some disagreement as to when the mill was originally built, with sources claiming 1723, 1791, 1800, or 1818. What is most likely the case is that several different mill buildings occupied the site before the Yeomans family came to operate the mill around 1800. The original alignment of Franklin Lake Road can be seen passing over the bridge to the immediate left of the mill. The mill is being re-sided in this picture. (Courtesy McBride family.)

The concrete arch bridge with wrought iron railings traverses over Pond Brook. The mill was rebuilt by MacKenzie around 1900 after a fire. (Courtesy McBride family.)

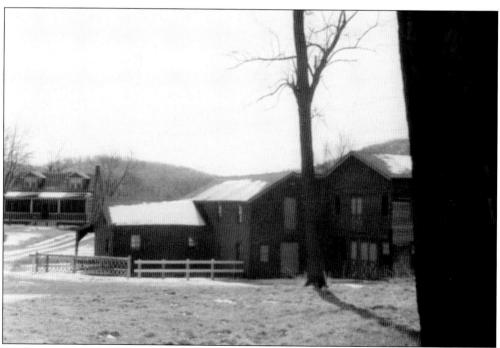
The Yeomans-Bender house seen at center left housed the foremen during the working life of the mill. In 1896, the Bender family took over operations at the mill for MacKenzie, who granted in his will life rights to the house, the mill, and the four acres they stood upon. (Courtesy McBride family.)

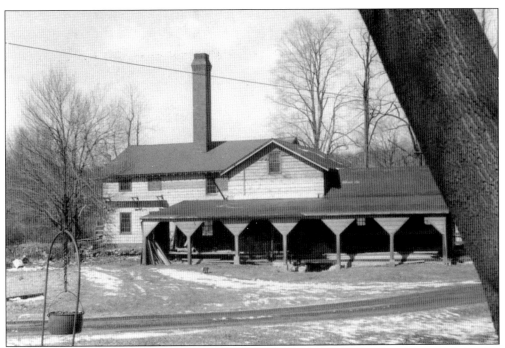

The large cutting blade of the sawmill can be seen in the third open bay from the left. The chimney stack from the steam engine stands tall over the landscape. (Courtesy McBride family.)

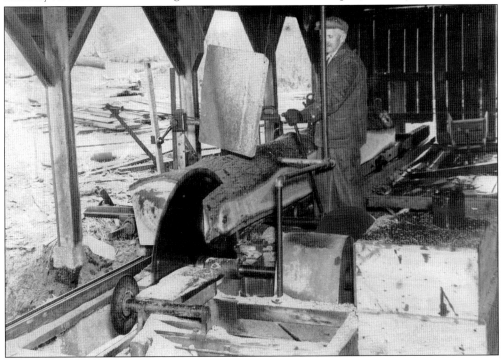

This 1930s picture is the only known image of the sawmill in operation. It was powered by a steam engine that was installed to ensure the mill operated in times of low water. Fred Bender is seen operating the mill. (Courtesy Mabel Ann Watkins.)

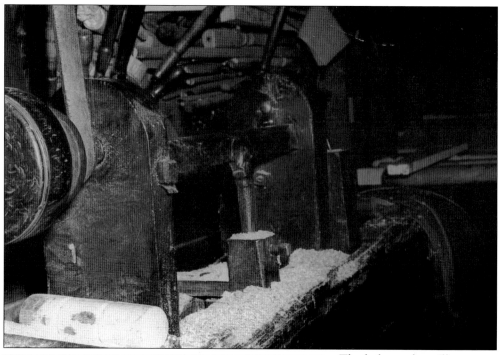

The lathe at the mill was unusual in that it was constructed entirely of wood by Dan Yeomans prior to 1860. The balusters of the railings at the Wyckoff Reformed Church were turned here. Leather belts hung from turning gears in the ceiling; to accommodate for different speeds, the belts were moved by hand to gears of different radiuses. (Courtesy Mabel Ann Watkins.)

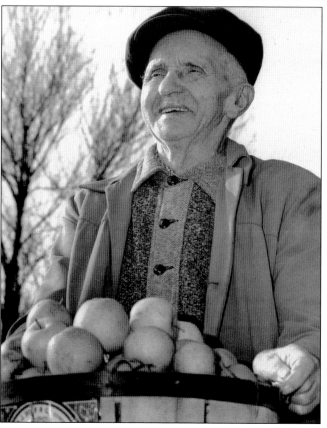

Fred Bender operated the mill until his death in 1962, sixty-four years after he first took over from the Yeomans family. (Courtesy Mabel Ann Watkins.)

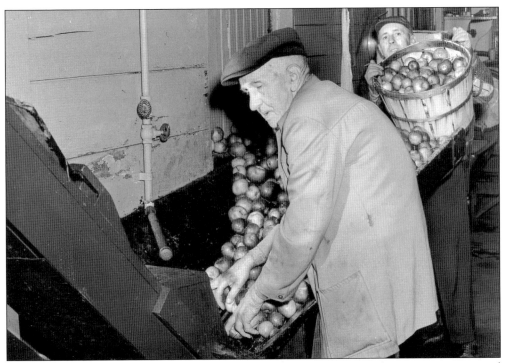

Fred (left) and Roy (right) Bender load and wash apples before they are taken up a water-powered conveyor belt to be cut. (Courtesy Mabel Ann Watkins.)

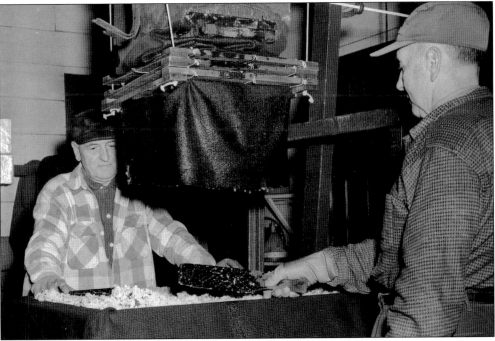

Robert (left) and Roy (right) Bender distribute the cut and ground apples into a rack that will be stacked under a massive press that will squeeze the juice out of the apples. At this point, the apples are referred to as "mash." (Courtesy Mabel Ann Watkins.)

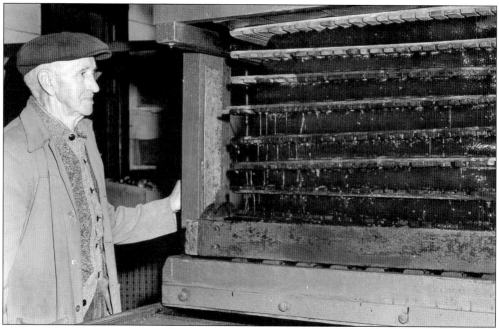

Fred Bender oversees the pressing of the mash. The water-powered press exerted 60 tons of pressure to extract the apple's juice. A bushel of apples, about 42 pounds, gets three gallons of cider. (Courtesy Mabel Ann Watkins.)

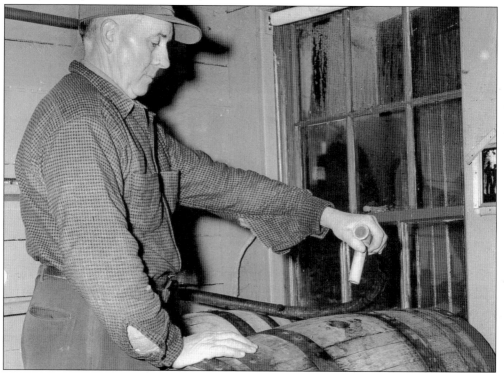

Roy Bender oversees cider being moved from a large storage tank into wooden barrels to age the apple cider before it is sold. (Courtesy Mabel Ann Watkins.)

An unidentified man stands next to an icebox and an unidentified piece of equipment, probably in the machine shop of the mill. (Courtesy Mabel Ann Watkins.)

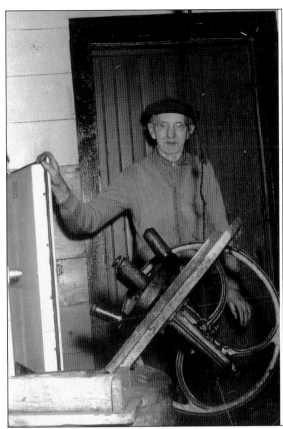

When the mill was rebuilt around 1900, the waterwheel was moved underneath ground level, allowing it to operate during freezing conditions with the water that flowed under the ice. Possibly manufactured by the Watson Machine Company in Paterson, this contraption was called the Perfection Waterwheel. The sluiceway and millpond can be seen leading up to the waterwheel. The clubhouse of the Indian Trail Club can be seen in the background. (Courtesy McBride family.)

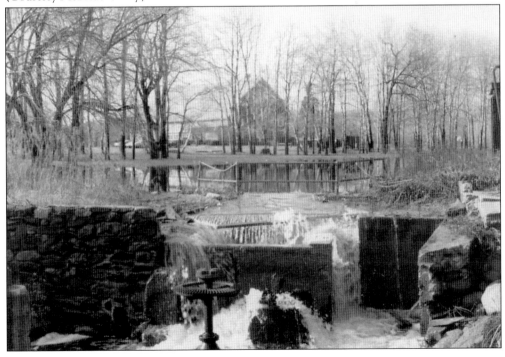

Here are members of the Vermeulen family at their Franklin Lakes farm, located somewhere in between Ewing Avenue and High Mountain Road, where the family had several dwellings. It is believed that Isaac Vermeulen is pictured at center. (Courtesy the Mola family.)

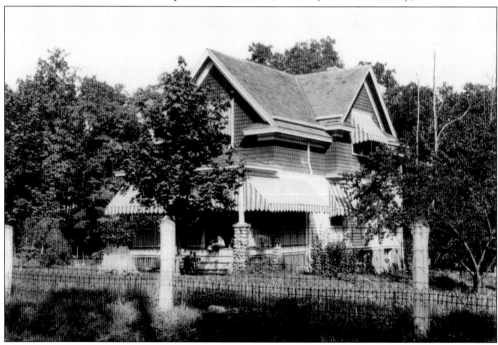

The DeKorte farmhouse on High Mountain Road was built around 1910 by James DeKorte and his wife, Nettie Vermeulen, on Vermeulen family land. Today, this house would have been on the eastern corner of Kuliana Court and High Mountain Road. (Courtesy Franklin Lakes Library.)

The garage and stable building behind this farmhouse was the first home of the Franklin Lake Dairy, founded in 1910 by James and Nettie DeKorte. The small attachment was the original plant. The delivery route at that time was 87 quarts a day, equivalent to almost 22 gallons. According to Nettie, at the peak of the dairy's operation, it was 10,000 quarts a day. (Courtesy Franklin Lakes Library.)

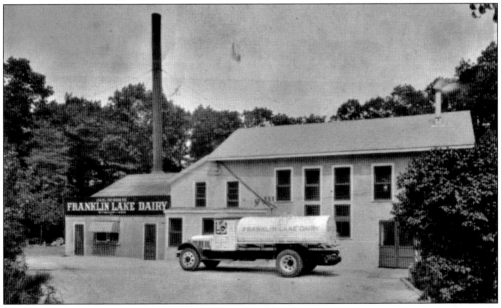

The business had grown considerably by the time this photograph was taken in the early 1930s. The facility with a large smokestack attached to a commercial boiler ensured pasteurization of the product before it was bottled and sent out with the milkman for delivery. (Courtesy Colin Knight.)

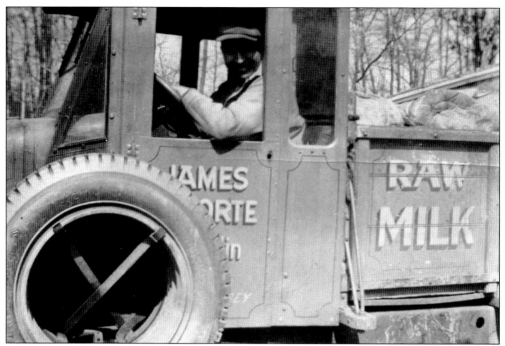

A man believed to be James DeKorte is shown in a heavy-duty truck, off to conduct business for his growing enterprise, which started with a milk route he purchased in 1909. (Courtesy Jack Goudsward.)

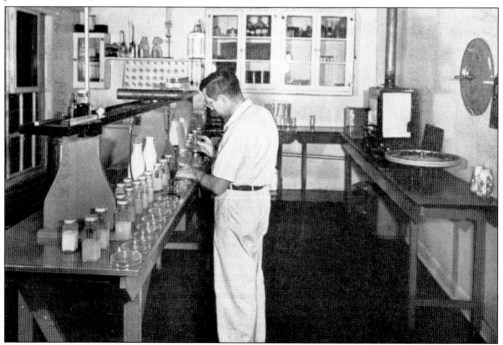

To ensure purity, milk was sampled upon arrival from the dairy herd in Sussex County. Before pasteurization became standard practice in the 1930s, milk quality was not guaranteed. Testing ensured that milk was free of worms and other parasites. (Courtesy Paulette Ramsey.)

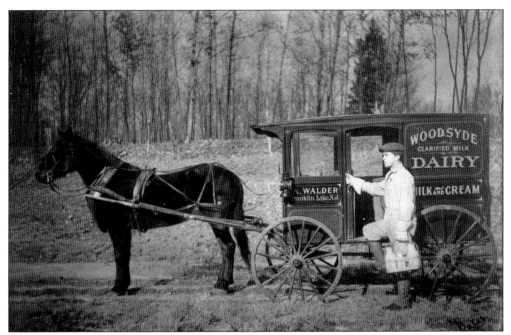

Future councilman Arnold Walder stands next to his milk delivery wagon. The Walder property was located near the corner of Ewing Avenue and High Mountain Road. The location given on the wagon, Franklin Lake, was the name of the settlement located in the southern half of town prior to 1922. (Courtesy Jack Goudsward.)

This c. 1957 photograph, taken looking toward the present-day site of the Church of the Most Blessed Sacrament, depicts the intersection at Franklin Lake and High Mountain Roads. (Courtesy McBride family.)

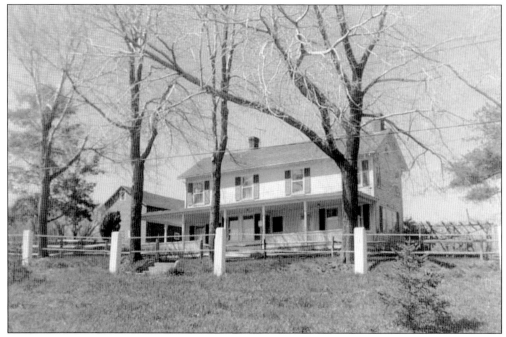

The original McKenzie farmhouse was located on the shores of Franklin Lake. At one time, McKenzie was one of the largest landholders in Franklin Lakes and hired many local men to work his lands. When he died in 1946, he left his property to the Archdiocese of Newark. Today, his estate includes the South and West Gates of the Urban Farms development. (Courtesy McBride family.)

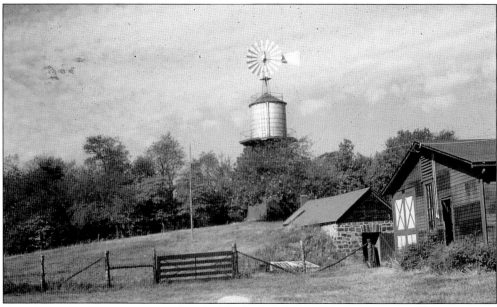

Note the windmill, water tower, and outbuildings on Franklin Lake Road in this 1959 photograph. The 2,100-acre property was owned by John McKenzie, one of the largest landholders in Franklin Lakes until his death in 1943. The water tower was restored in the early 1960s to its current appearance and can still be seen on Longbow Drive. (Courtesy Birrer family.)

Cows were a common sight in Franklin Lakes during its agricultural heyday. Dairy farming was heavily concentrated in the lower half of town, with at least four dairies operating in the region over time. (Courtesy McBride family.)

This frame house, located across Franklin Lake Road from the cider mill, was home to Josiah Yeomans, whose family operated the mill for over a century. Roy Bender, who worked the mill with his family after the Yeomans, tells a story of York Benson, who lived in this house around 1910. Benson was an African American farmer who kept cows and sold butter at market in Paterson. (Courtesy McBride family.)

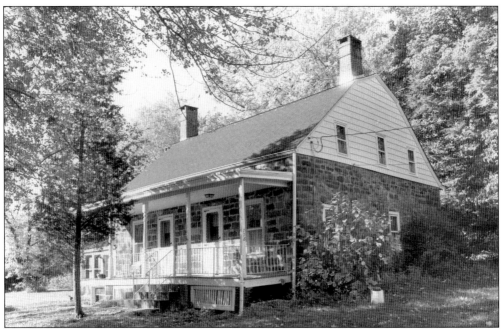

Here is another view of the Van Houten house, which was located up the hill from Franklin Lake on Vee Drive. Van Houten family members were prominent farmers and landowners who sold produce locally as well as at major markets in Paterson and New York City. (Courtesy Franklin Lakes Library.)

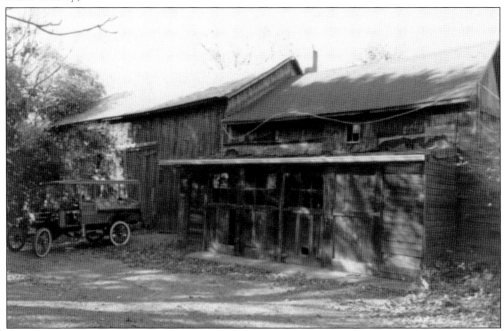

Here is one of several outbuildings on the Van Houten property. This picture was taken in 1966 when Karel de Waal Malefyt purchased Van Houten's produce delivery truck. The state of the building and mature trees show how large-scale farming was no longer happening at the homestead. This was typical for most farms in town at this time. (Courtesy Franklin Lakes Library.)

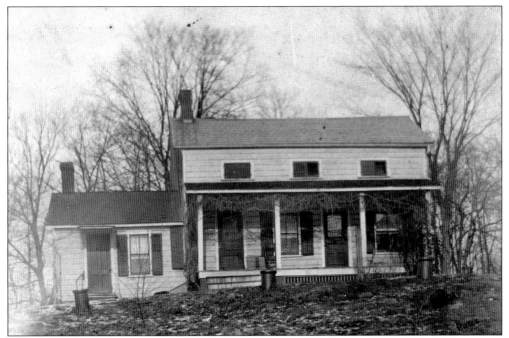

The William Packer house was located on Ewing Avenue across from today's Lorrimer Nature Sanctuary. Dating back to the 1700s, the Packer family farmed much of town along Ewing Avenue. (Courtesy Franklin Lakes Library.)

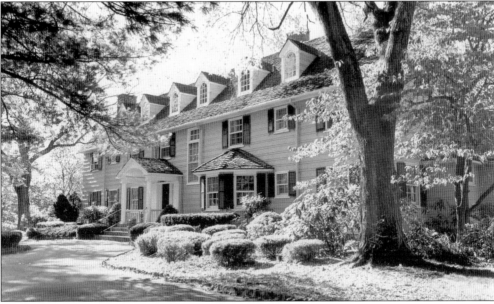

Franklin Lakes was a popular area for wealthy gentlemen farmers to own land "out in the country," where a large estate with a manor house would be overseen by caretakers while the owner and his family would use the land as a vacation destination and getaway from city life. The Atterbury-Brockhurst house on Ewing Avenue is a prominent example of such a dwelling. Built in stages between 1902 and 1913, the home was completely rebuilt in 2006 after a serious fire. Famous portrait artist Gerald Brockhurst lived here for several decades. (Courtesy Jack Goudsward.)

The E.H.H. Simmons house, located on the southeast corner of Franklin Lake Road and Ewing Avenue, is another example of the country estates that were built in town at the beginning of the 20th century. Simmons was related to the Harriman family of political and railroad fame and is best known as the president of the New York Stock Exchange from 1924 to 1930. (Courtesy Franklin Lakes Library.)

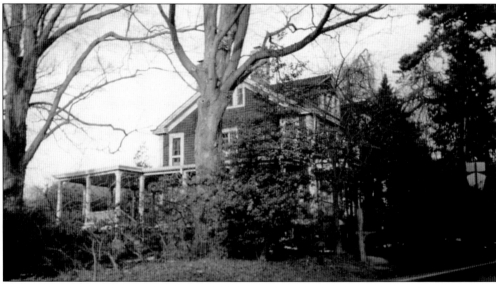

The Ackerman-Roehrs homestead, like many houses in the area, consisted of several sections built over time. The middle section of this house, not pictured, is considered the oldest, dating back to the Revolutionary War. Several sources state that this original section was a stagecoach stop and inn. The Roehrs family believed that the pattern of wear on the original stone cellar stairs looked as if barrels had been rolled down them, adding to the legend. In 1809, James I. Ackerman lived here, and it was later purchased in 1894 by Bernard and Louise Ewing. A massive fire in 1907 destroyed more property than was insured for, sparing the house, and Ewing sold off sections of the land, finally moving out in 1914. (Courtesy McBride family.)

Five

FARMS TO SUBURBS

When Tri-Corner Realty, headed by William Kalff and Andrew DeBoer, built the first planned community along Colonial Road, Franklin Lakes was unknowingly ushered into both the motor age and the suburban age. The development consisted of a strip of stores, the first of their kind in town, along with 17 homes with attached garages. After World War II, Kalff headed the Franklin Lakes Heights Development Company and developed Crystal Lake Terrace, Pines Terrace, and, later, Hilltop Terrace. Farms dwindled as property values went up, with many longtime families selling the family homesteads after generations of ownership. The death of John Mackenzie freed up a significant amount of land in the southern portion of town, which was acquired by Urban Farms in the late 1950s. Urban Farms established the Indian Trail Club on Franklin Lake and built the Urban Farms Shopping Center to support the 700 acres of land it would develop. Edward C. May owned over 300 acres off Old Mill Road, where he built the Shadow Lake Beach Club; this property was later sold in 1956, and Shadow Lake Estates was built by the H.D. Land Co. Inc.

Longtime businesses either adapted to changing clientele or shuttered. The Pulis family sold their mill in 1958; their final years of business were primarily delivering heating coal, a feature absent from the newly built homes. By the end of the 1960s, Franklin Lakes had transformed from a sleepy rural community into a busy suburb.

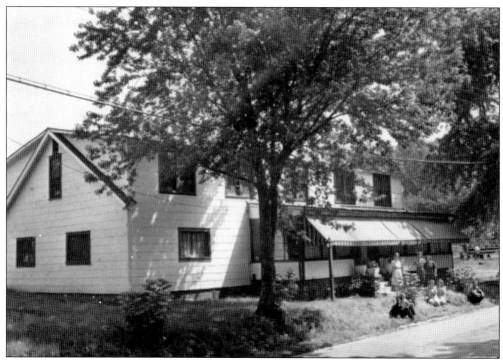

This unidentified building is said to have been on Franklin Avenue close to the Oakland border. It originally served as a seasonal boardinghouse, which were abundant in the area from the 1890s until the 1930s. It was later converted into a commercial embroidery mill by the Mutzberg family, one of several that operated in the borough. (Courtesy Franklin Lakes Library.)

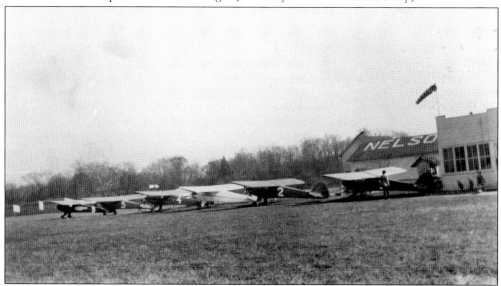

The Franklin Lakes Airport opened for business in 1932 under the management of Don Nelson with H.E. Merchant as instructor and mechanic. The airfield was located along Franklin Lake Road between what is today Kent Place and Colonial Road on land rented from the Fletcher estate. Activities on-site included air shows, parachute jumps, aerial photography, and even airmail. (Courtesy Franklin Lakes Library.)

According to local newspapers at the time, crashes were not uncommon at the airport. Issues with permitting and various licenses, driven by complaints from neighbors and local farmers, drove the push to end operations at the airfield in 1941. As the land was developed over the years, residents recall digging all sorts of airplane parts out of the ground nearly 30 years after the final flight. (Courtesy Franklin Lakes Library.)

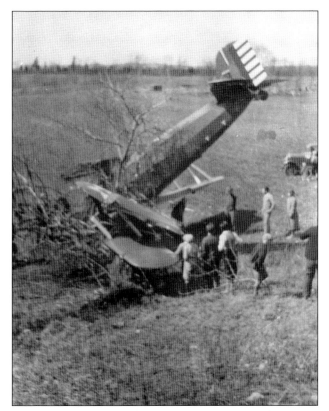

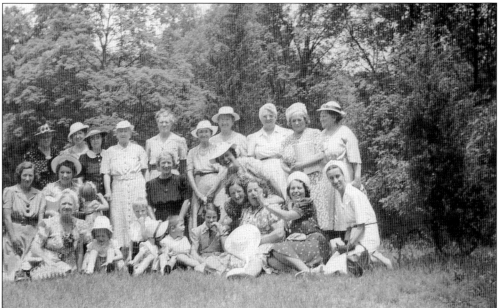

An early social club in town, the Rainbow Garden Club was established in 1927 and was active in the community up to the 1970s. The club worked with the town and local civic organizations to plant decorative flowers in public areas. An early project was coordinating plantings around the Zachariah Masker memorial honoring the fallen World War I hero. (Courtesy Mabel Ann Watkins.)

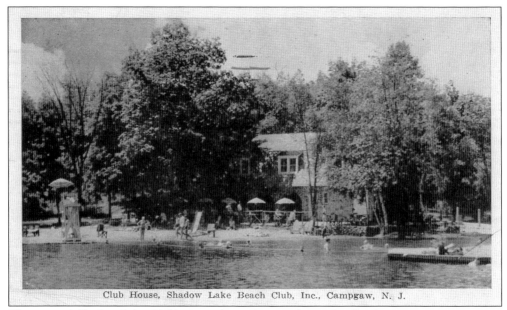

The original Shadow Lake Clubhouse is located on Loch Road, off Pulis Avenue. In a previous life, it was the carriage house of the nearby Albert Pulis home. Shadow Lake Club had multiple beaches along the shore, and in addition to swimming, it offered tennis and canoeing. The back of this postcard is dated 1941. (Courtesy Colin Knight.)

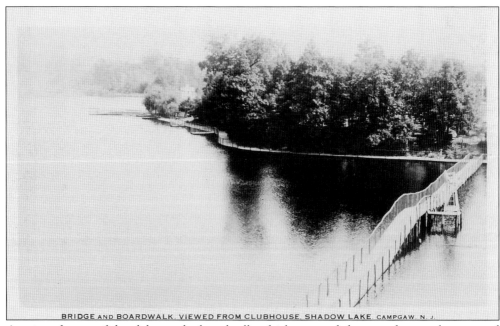

A unique feature of the club was the boardwalk, which spanned the waterfront and connected the different recreation areas. (Courtesy Susan Pulis.)

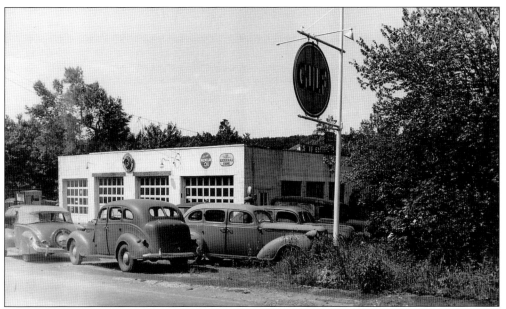

The William Gass Service Station was located near the Franklin Avenue railroad crossing; in addition to automotive work, the Gass family also ran a heavy machinery business. (Courtesy Roger Ahl.)

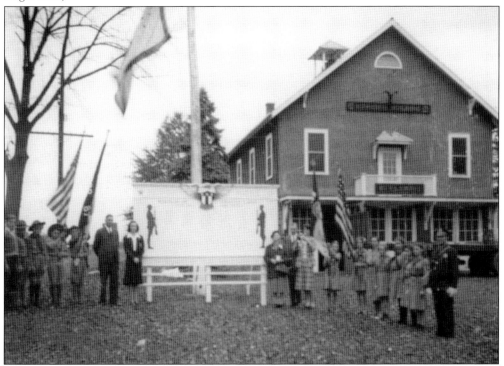

On October 17, 1942, over 150 people gathered at the dedication ceremony for the World War II Service Honor Roll. The roll recognized 50 service members and was donated by James and John DeKorte. In this rare picture, local Boy and Girl Scouts lead the crowd in a salute to the flag. (Courtesy Franklin Lakes Library.)

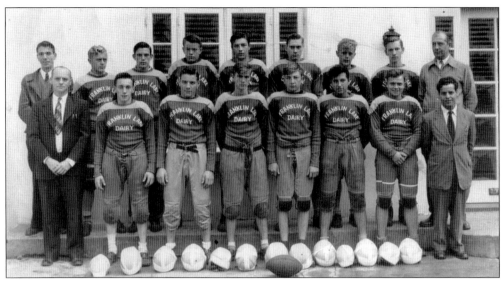

The Franklin Lake Dairy sponsored a local football team for several seasons. The leather helmets were painted blue with white visors and padding; the task was done by Herb Potts, sign and letter painter for the dairy, with the paint on hand at the shop. Pictured are, from left to right, (first row) manager J. Cooper, A. Van Syckle, R. Burns, W. Miller, D. DeKorte, A. Gitto, G. Anderson, and coach A. Fava; (second row) unidentified, D. Ringers, W. Mankowitz, N. Sisco, J. Bockhorn, J. Kummerfeldt, J. Ringers, unidentified, and John DeKorte, Franklin Lake Dairy owner. (Courtesy John Bockhorn.)

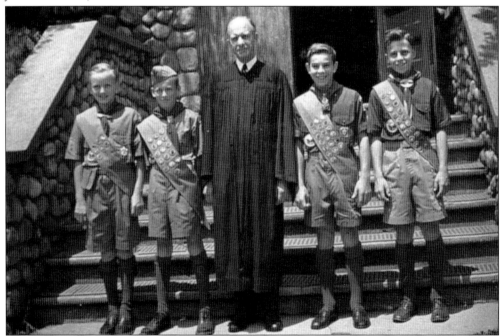

Boy Scout Troop No. 34 held a contest in 1953 to see which Scouts would get to attend the National Jamboree happening later that year in Irvine Ranch, California. The Scouts who scored highest in a skills competition were, from left to right, Jim Piccoli, Richard Steves, Edward Piccoli, and Joseph Caggiano. Rev. R.W. Ricketts is seen in the middle. (Courtesy Joseph Caggiano.)

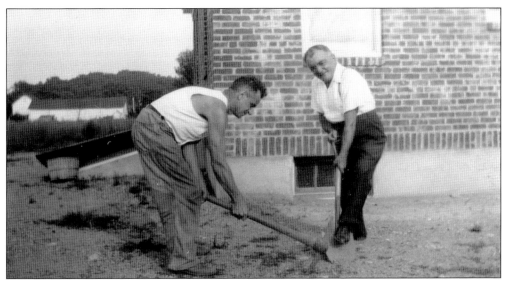

New residents John Maronpot (left) and Mario Perino (right) work the ground at the Maronpot home built on the location of the old airport. The Fletcher barns, which acted as hangars for Nelson Airport, can be seen in the background. (Courtesy Rulli family.)

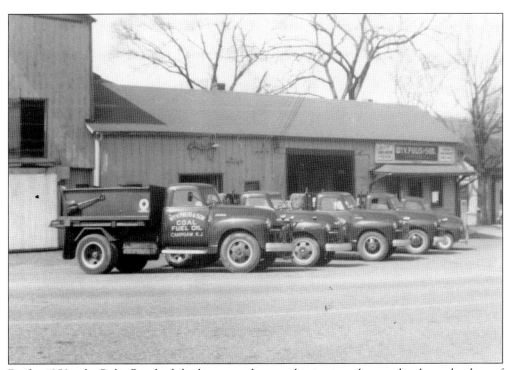

By the 1950s, the Pulis fleet had shed its ox and wagon beginnings, but a yoke above the door of the 1871 building reminds customers of its humble origins. (Courtesy Susan Pulis.)

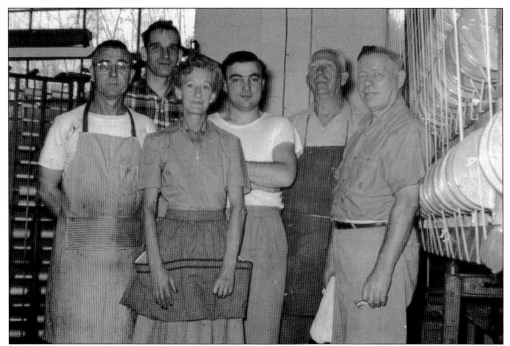

Employees of the Campgaw Woven Label Mill pose for a photograph in 1954, which was when the mill was located behind the stores on Franklin Avenue. Second from right is World War I veteran Dick Van der Laan, father of Mabel Ann Watkins. (Courtesy Mabel Ann Watkins.)

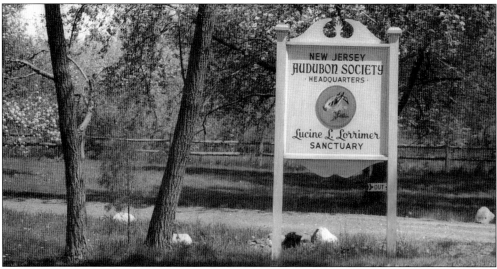

Lucine Lorrimer was the last private owner of the Clapp-Cooke estate on Ewing Avenue, known as Applewood Farms in her time. Upon her early death in 1954, she bequeathed her 14-acre estate to the New Jersey Audubon Society. The organization moved its headquarters to the home and was based out of there until 1984. Almost 70 years later, Lorrimer's vision to preserve her farm gives guests a glimpse into the only historic home and gentleman farm open to the public in town. Over the last several years, original features of the home have been lost in order to adapt to changing public building requirements, but it still offers a glimpse into what manor homes were like in the 1910s in Franklin Lakes. (Courtesy Colin Knight.)

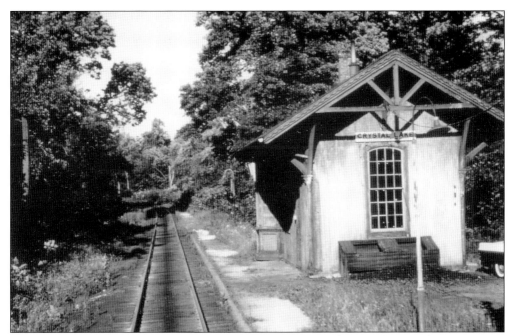

The Crystal Lake Station was torn down not long after this photograph was taken in 1960; it was disposed of in the swamp along the railroad tracks. The station had not been staffed since 1928, and only a handful of commuters were being served here at this time. (Courtesy Franklin Lakes Library.)

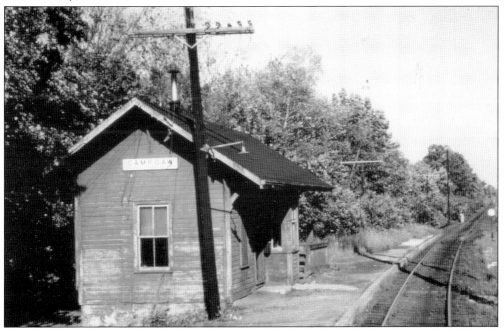

With Franklin Lakes slowly turning into a two-car household community, rail travel fell to the wayside, and stations were not maintained. Freight service to the Pulis Mill had been replaced by trucking. The Campgaw Station was torn down shortly after the station at Crystal Lake. (Courtesy Franklin Lakes Library.)

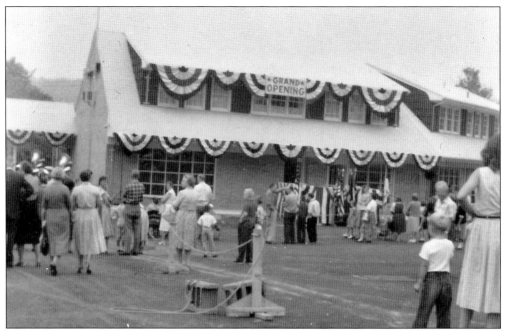

In 1960, the Franklin Lakes Post Office moved from Pulis Avenue to a building located on Franklin Avenue. This building still stands today and is not far from the current post office. To date, the Franklin Lakes Post Office has been located in seven different buildings, the only entity in town to have so many different locations. (Courtesy Susan Pulis.)

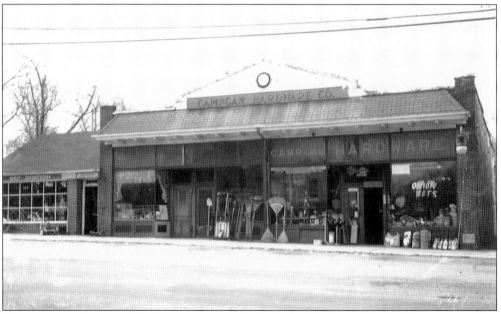

The commercial strip on Franklin Avenue was built by the Tri-Corner Realty Company in 1931. The Campgaw Hardware Store was a fixture in town and ended up expanding several times, taking over neighboring storefronts and also having an annex built off the side of the building. Campgaw Hardware was the longest tenant, remaining until the demolition of the store in 2015, when it was known as True-Value Hardware. (Courtesy Franklin Lakes Library.)

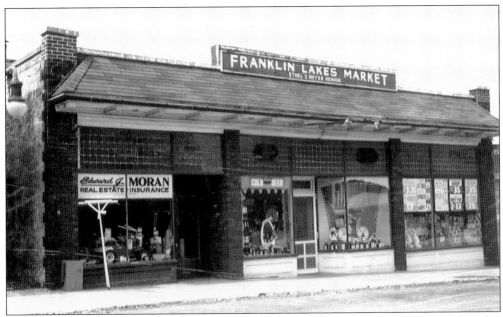

The Franklin Lakes Market was the only grocery store in town pre-1960, which was when this photograph was taken. When it was first opened as the Colonial Market in 1931, it replaced Wyckoff as the closest market for residents. It was also the only store in town permitted to sell cold beer; Les's Delicatessen was only allowed to sell warm beer under its license. (Courtesy Franklin Lakes Library.)

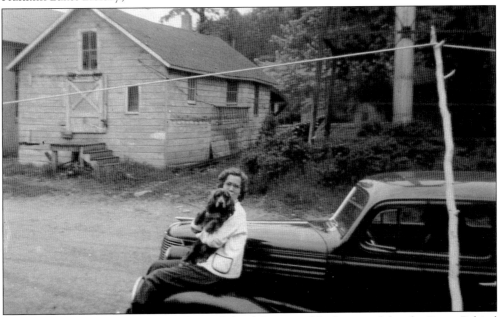

Mabel Ann Watkins is seen in the alleyway behind Campgaw Hardware with her dog Rusty. Behind the stores on Colonial Road was the residential portion of the Tri-Corner Realty development, which is where she lived with her husband, Jim, when they were first married. The footings for the water tower and a shed used by the hardware store can be seen behind her. (Courtesy Mabel Ann Watkins.)

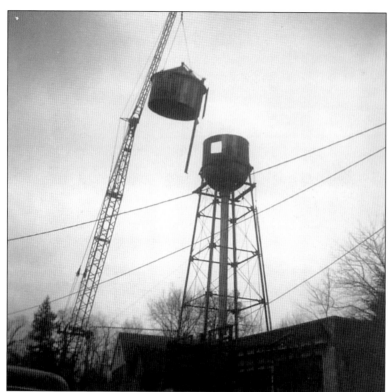

After a protracted argument with the town, Tri-Corner Realty agreed to remove its water tower and fold the private utility company that served the businesses and residences along Colonial Road and Franklin Avenue. In 1963, the tower was removed, and a central water line was run through the downtown area. (Courtesy Roger Ahl.)

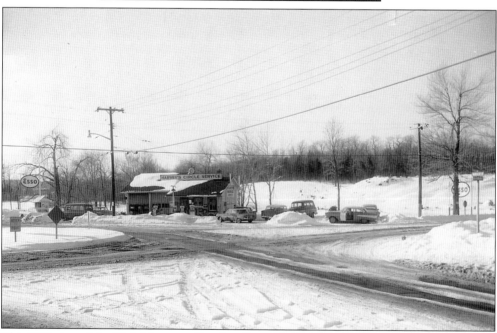

This 1961 view of the High Mountain Road traffic circle shows the only business operating there at that time. Harvey's Circle Service was originally built in 1924 by Walter Snyder and was the first gas station in town. Shortly after this, it would be torn down, and the Franklin Lakes National Bank would be built behind it. (Courtesy Paulette Ramsey.)

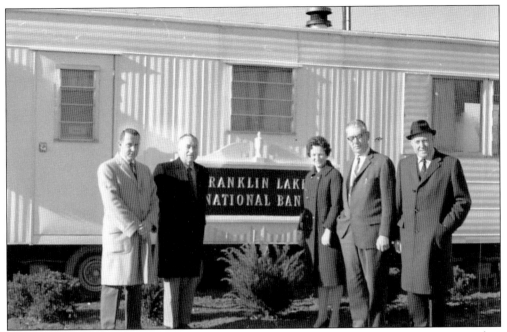

As part of McBride's Urban Farms development, the first bank was brought to town. Prior to this, the nearest bank was the Wyckoff Savings and Loan Association, and many local men sat on the association's board over the years. This construction office was located at the High Mountain Road traffic circle, where the shopping center is today. (Courtesy McBride family.)

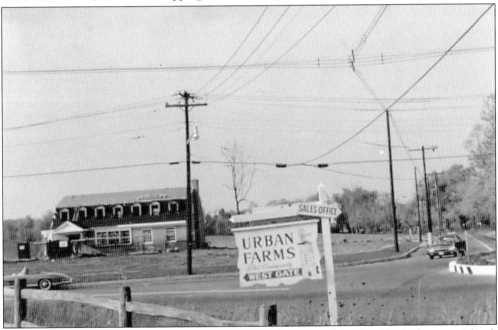

In 1962, Urban Farms was moving along with its development of the Franklin Lake area. A bank would be the first built in town and was centrally located to the residential developments that had begun that year. A sign with the windmill advertises the West Gate development and points prospective buyers to the sales office. (Courtesy McBride family.)

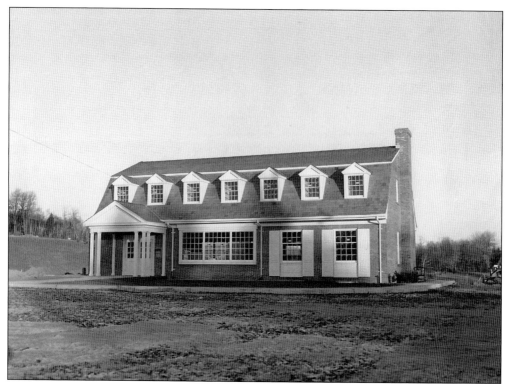

The bank building was the first edifice erected in a planned shopping center, which was completed in 1963. The hill seen to the left would slowly be carted away to create a clear and level site for future additions. (Courtesy McBride family.)

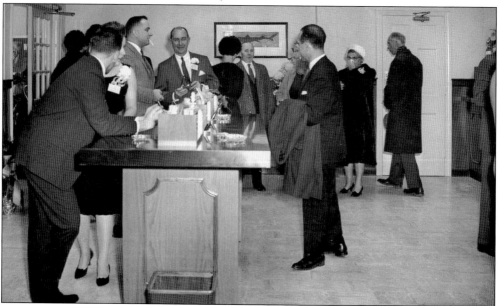

Taken at the grand opening of the bank, this photograph depicts J. Nevins McBride standing at the end of the lobby table. Councilman Roy Bender is seen in front of the painting on the rear wall. (Courtesy Mabel Ann Watkins.)

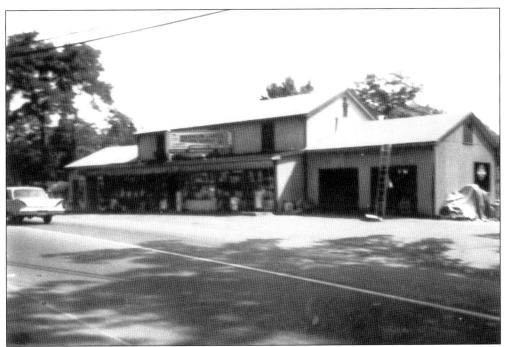

The Franklin Lakes Building Supply Company was located on Franklin Avenue across from the school. It was operated by the Langendoen family until 1987. Prior to that, the grounds were the winter headquarters of Heller's Carnival and Amusements. (Courtesy Franklin Lakes Library.)

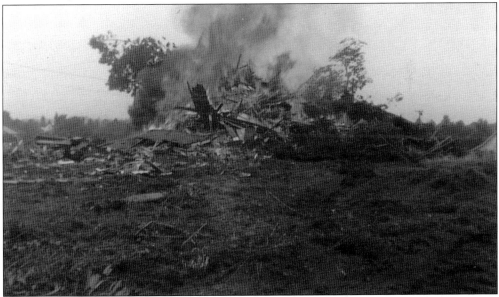

The long anticipated extension and modernization of Route S4-B, later known as Route 208, came to Franklin Lakes in 1962. Prior to that, it was a dirt access road that picked up at Russell Avenue in Wyckoff where the pavement ended. Several homes were demolished to improve the roadway, including the Charlie Winters house near Summit Avenue. Rather than dispose of the debris, homes were demolished and burned, and the ashes were tilled back into the soil. (Courtesy Franklin Lakes Library.)

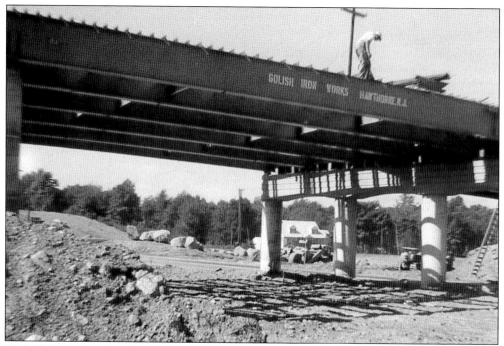

With the improved highway, the need for overpasses came. The construction of the Summit Avenue overpass took place in 1962. This photograph was taken from the front porch of the Edwards family cabin, which would be demolished shortly after. (Courtesy Franklin Lakes Library.)

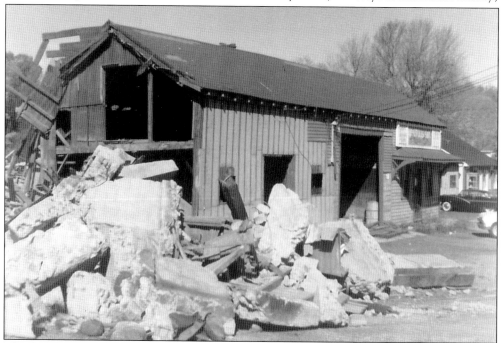

The family interest in the Pulis Mill was sold in 1958. The new owners demolished the buildings in 1963 to make way for the Susquehanna Avenue commercial development. The oldest part of the mill, built around 1871, can be seen center left. (Courtesy Susan Pulis.)

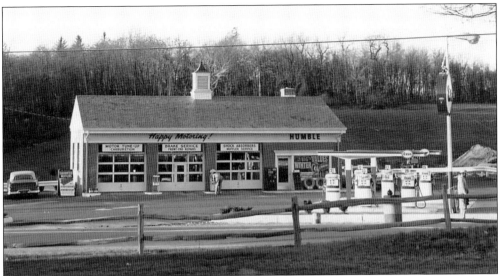

Next to open at the Urban Farms Shopping Center was the Humble Esso service station, located today where the bank building is on the edge of the property. A stark contrast to Harvey's Circle Service, the Humble Esso reflected the changing styles of the region with the suburban boom. (Courtesy McBride family.)

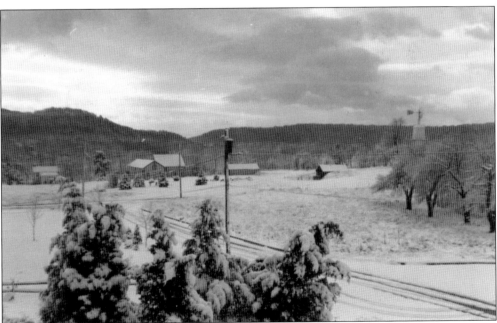

Meanwhile, streets were being laid out all across Urban Farms in anticipation of new residents seeking country living. Arrow Lane is seen in the foreground, and Longbow Drive runs along the back of the McKenzie farmhouse property. (Courtesy McBride family.)

A typical Urban Farms home is seen here. There were several layout plans that could be purchased to meet the needs of future occupants. (Courtesy Franklin Lakes Library.)

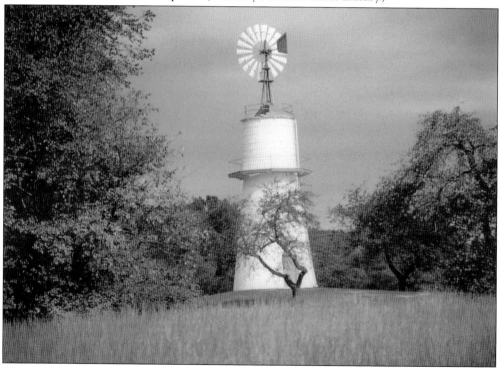

This covered-up water tower served the McKenzie estate and is an iconic part of the Franklin Lake landscape, having been used in several Urban Farms logos and publications over the years. The windmill pumped water up to the tank and provided water pressure to the farmhouse and select outbuildings. (Courtesy McBride family.)

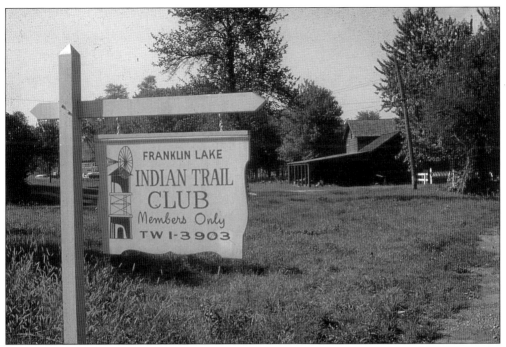

The early insignia for Urban Farms is seen on this sign for the Indian Trail Club. Both the cider mill and clubhouse can be seen in the background. (Courtesy Birrer family.)

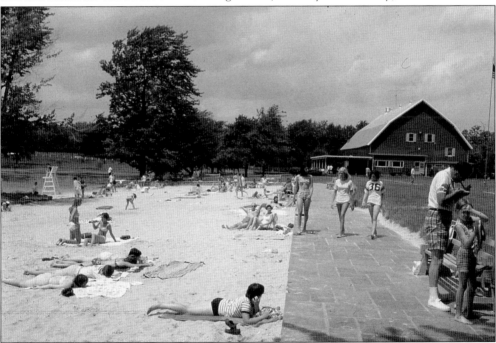

The Indian Trail Club was based out of a barn that was affiliated with the McKenzie estate, and though heavily altered through the years, it still retains a similar look, calling back to a day when there were more barns than buildings in town. By the time this photograph was taken in 1967, hay farming along the lake was replaced by beachfront activities. (Courtesy Birrer family.)

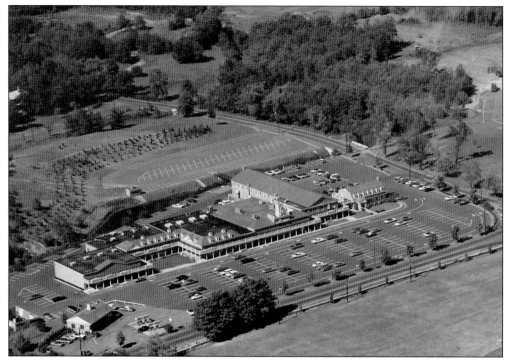

This late-1970s aerial shows the completed Urban Farms Shopping Center. Longtime residents recall Acme, Urban Pharmacy, Huffman/Boyle, and the Urban Spa. (Courtesy McBride family.)

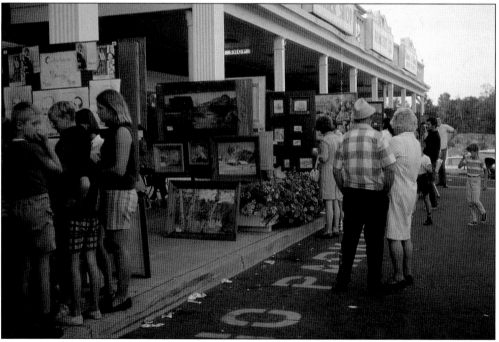

The Urban Farms Art Show started off as a one-day event in 1964 but quickly bloomed into a weekend-long affair. Local kids have excitedly gathered around a caricature artist at a bargain at $2 per portrait. (Courtesy Birrer family.)

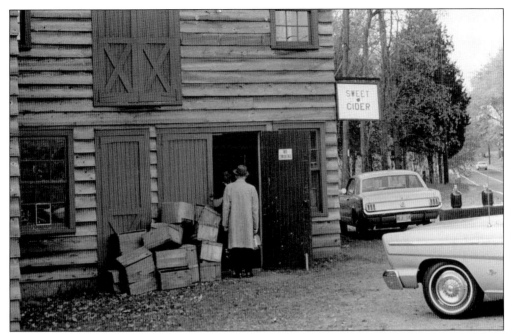

People would come from all over North Jersey for a gallon of fresh cider pressed on-site by the Bender family and, later, by employees of Urban Farms. One local resident still asserts that it was the best cider she had ever had, nothing compared to watching tapped barrels empty out into the glass jugs. (Courtesy Jim Longo.)

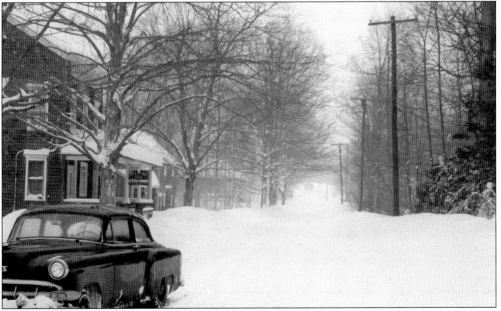

When this photograph was taken in the late 1950s, the Crystal Lake Inn had presided over the sleepy portion of High Mountain Road that it fronted for almost 90 years. The extension of Route 208 to Oakland cut the section of road that connected to Franklin Avenue in Oakland, leaving the inn at the bottom of a dead end street. The barn and horse stalls that served the inn can be seen behind the sign. (Courtesy the McBride family.)

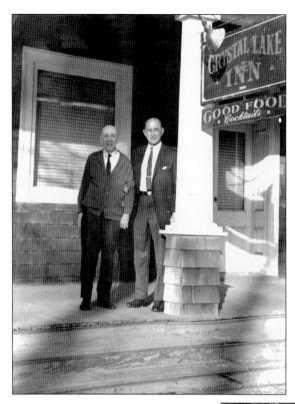

Gus Hilbig (left) assumed responsibility of the Crystal Lake Inn upon his father's passing in 1917. The Hilbigs purchased the business in 1916 and were the third family to tend bar along the sleepy stretch of High Mountain Road. Hilbig ran the inn for 50 years before hanging up his hat in 1966. The inn was witness to large changes in town, primarily the coming of the highways. When the doors were locked for the last time, the inn was on a short dead end street that saw minimal foot traffic. Hilbig only opened for special occasions—a far cry from the roadhouse stop it once was. (Courtesy McBride family.)

Jim Longo is seen here at Buttermilk Falls, where he long led informative walks between the carved out traprock. He and his wife, Rosalie, resided in the Simeon Van Winkle house at the traffic circle. Longo led several efforts in town to preserve local history, including documenting the Crooked Pond Cemetery where Van Winkle is buried. He was a writer for the *Paterson Evening News* and wrote several stories on the history of Franklin Lakes and the historic cider mill he loved. (Courtesy Jim Longo and the Franklin Lakes Library.)

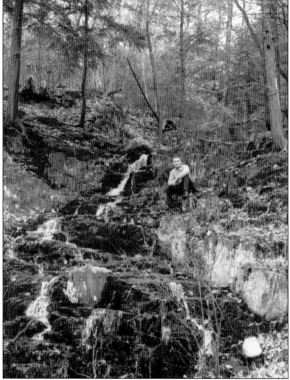

Fireman's Field with its recent improvements is pictured in 1967. Located on Franklin Avenue, Fireman's Field has been used by local teams and leagues since the late 1940s. Clam bakes were held at the field, and fire department parades ended here for many years. (Courtesy Susan Pulis.)

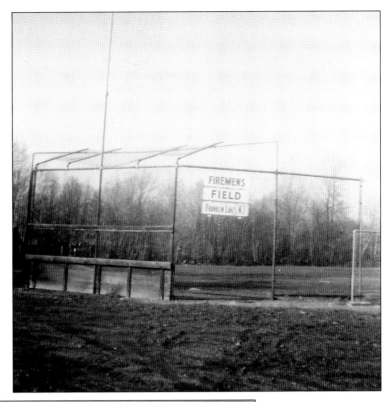

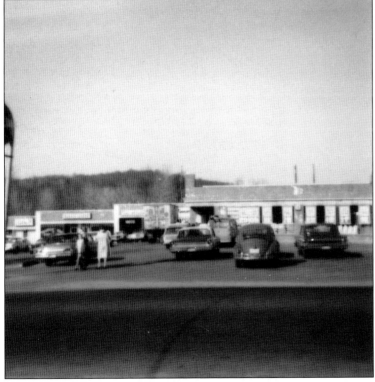

Foodtown came to Franklin Avenue in summer of 1961 and was the first full-service supermarket in town. By the time this picture was taken in 1967, additional retail space had been added on to the side. (Courtesy Susan Pulis.)

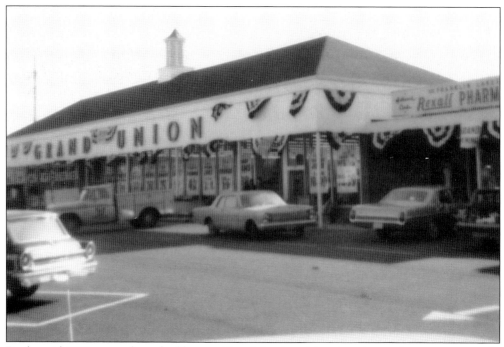

By the mid-1960s, more farms had been sold and developed into housing or shopping centers. In April 1967, the Grand Union opened on the site of the Charles Fox chicken farm at 820 Franklin Avenue. Today, this is the site of the Stop and Shop. (Courtesy Susan Pulis.)

This 1967 photograph shows the final iteration of the Campgaw Station. Torn down earlier in the decade, the station was no more than a concrete platform by the end of passenger service in 1966. The commercial siding at the Pulis Mill was taken up in 1963. (Courtesy Susan Pulis.)

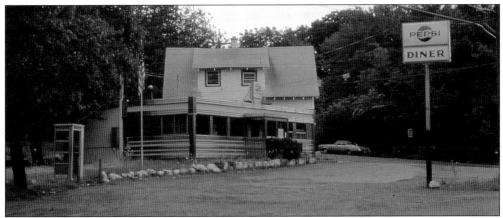

Bender's Diner started off as a farm stand on the corner of Franklin and Ewing Avenues, where Mary Bender sold pies in addition to produce. The diner stood until 1972, when the property was sold and a new restaurant was built in its place. (Courtesy Warren Storms.)

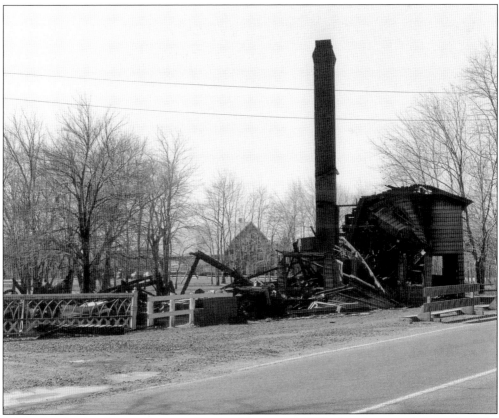

Taken shortly after the structure was destroyed by arson in 1972, this photograph shows the cider mill slowly collapsing inward while the chimney stack looks on. The Indian Trail Club clubhouse can be seen in the background. The bridge railing in the bottom left is a remnant of the original Franklin Lake Road alignment. (Courtesy Paulette Ramsey.)

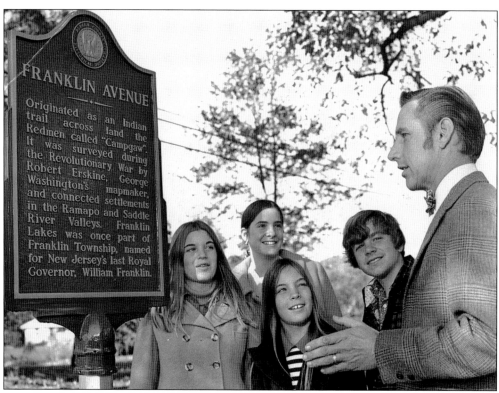

Architect and school board member George Downie talks with, from left to right, students Christi Ruane, Laurel Andreotta, Scotty Ruane, and Michael Wos about the historical significance of Franklin Avenue. Downie sponsored the historical marker, which is located outside of the commercial building he designed, Century Oaks. (Courtesy Priscilla Thoma.)

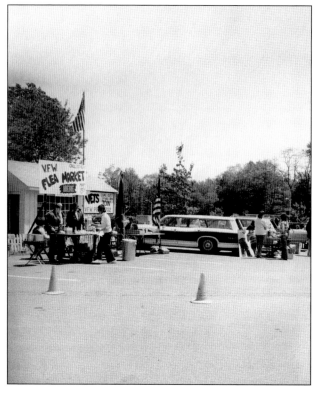

When the library moved from the municipal lot on the corner of Pulis and Franklin Avenues to the basement of the new borough hall on DeKorte Drive, the Veterans of Foreign Wars (VFW) took over the building. Flea markets were held as regular fundraisers for decades before waning interest brought them to an end in the early 2000s. (Courtesy Jack Goudsward.)

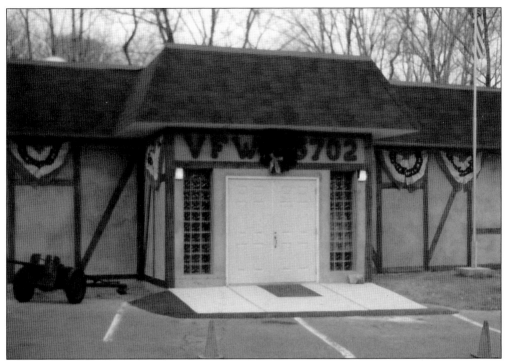

VFW Post No. 5702 had decided that it outgrew the old library building and put together manpower to build a new headquarters. (Courtesy Susan Pulis.)

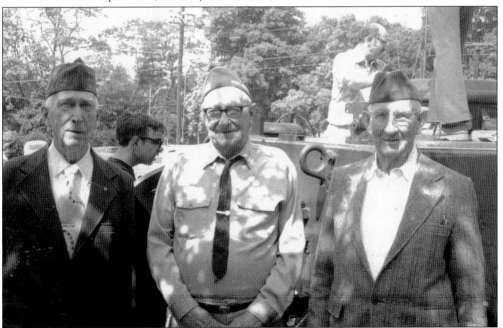

From left to right, local World War I veterans Dick Van der Laan, Nick Meyer, and Raymond Hopper pose in 1977 for the 60th anniversary of American involvement in the war. Hopper was known for still being able to fit into his World War I uniform at the ripe age of 90. (Courtesy Mabel Ann Watkins.)

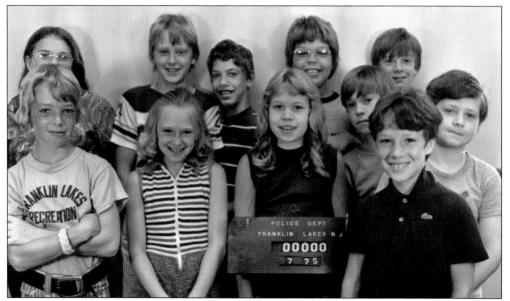

A popular summer camp program at the library was the visit to the police department, where children got their mugshots taken! Kids and Cops was a big success, and many fondly remember the summer library programs. (Courtesy Franklin Lakes Library.)

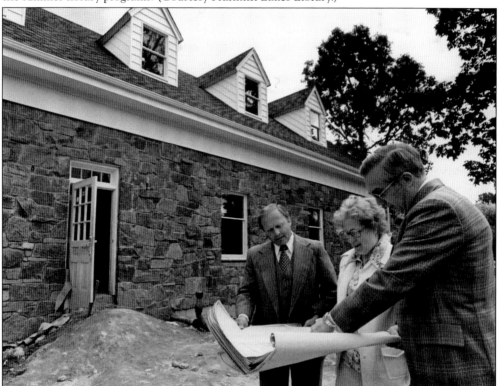

Bob Thorton, left, of IBM, a major donor to the Franklin Lakes Library Fund, looks at building plans with Barbara Thiele, library director. At right is George Voss, cochairman of the Furniture Fund Drive. (Courtesy Franklin Lakes Library.)

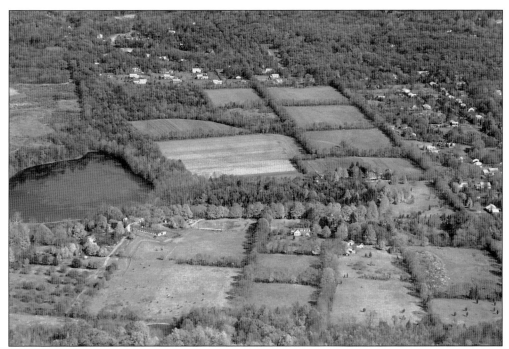

Here, housing developments are starting to encroach on the Walder and Lily Pond Farms. Franklin Lake Road cuts across the middle of the image, and Hopper's Pond is at center left. In the next decade, all the fields in this picture would be developed. (Courtesy McBride family.)

It might seem hard to believe that there were still dirt roads in town in the 1980s, but Connie Avenue would not be paved for another few years. (Courtesy Roger Ahl.)

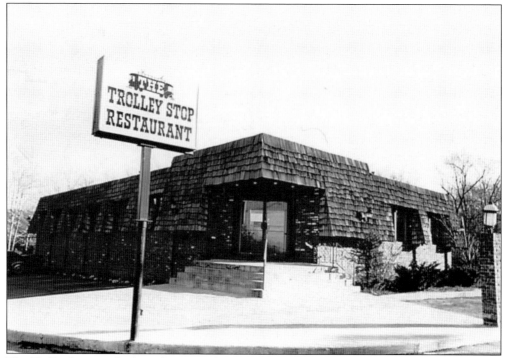

The Trolley Stop was built on the site of the former Bender's Diner and had seating for 150 people. It was originally intended to be open 24 hours, but an ordinance was passed. (Courtesy Roger Ahl.)

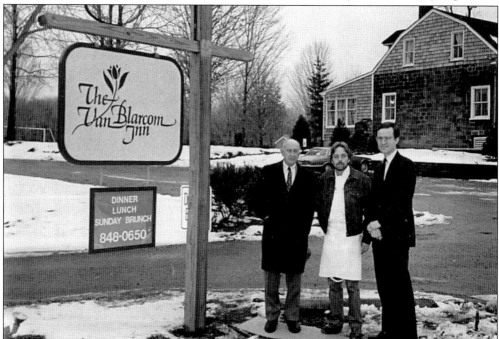

J. Nevins McBride had long wanted to open a restaurant that featured the cider mill, but destruction by an arsonist dashed those plans. The Van Blarcom Inn opened in 1985 and quickly became a four-star restaurant serving French, American, and Asian cuisine. (Courtesy McBride family.)

After the arson at the cider mill, McBride had looked into the possibility of reconstructing the mill. This project was heavily documented, and in 1976, a firm came out to inspect the area. Representatives looked over the ruins and determined the proximity to the water made reconstruction unfeasible. (Courtesy McBride family.)

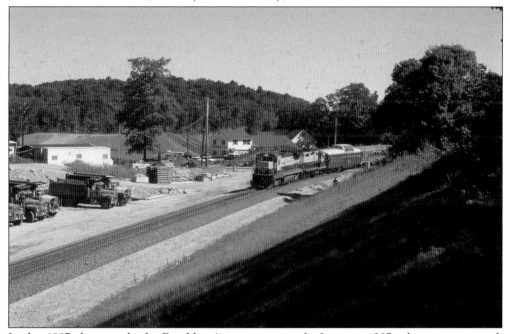

In this 1987 photograph, the Franklin Avenue overpass for Interstate 287 is being constructed, and the railroad line has been rerouted to accommodate the incoming federal highway. The Urban Autobody is seen at the center of the image. Still in business today, it is now called the Urban Auto Spa. (Courtesy Colin Knight.)

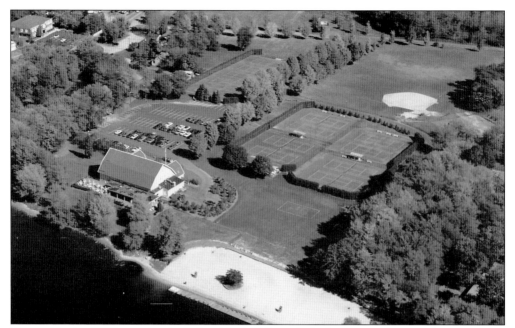

Pictured in this 1980s aerial is the Indian Trail Club, with the barn, waterfront, and tennis courts as the focal point. McBride Field, Urban Farms Shopping Center, and the mill site are seen in the distance. McBride's vision of a centralized business district and club to serve the development is on full display here, showing how an agricultural hamlet was transformed into a vibrant community. (Courtesy McBride family.)

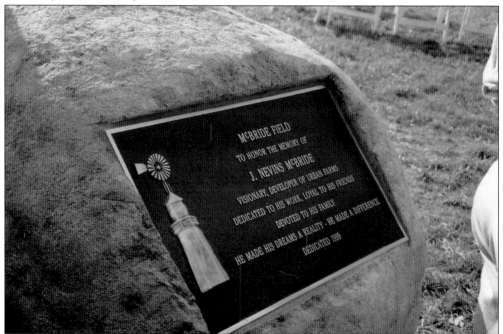

In 1999, the Borough of Franklin Lakes dedicated McBride Field in honor of J. Nevins McBride, whose family business developed most of Franklin Lakes in the second half of the 20th century. (Courtesy McBride family.)

Six

LOCAL GOVERNMENT

By the start of the 1920s, Campgaw, Franklin Lake, and Crystal Lake saw that their needs were changing and wanted to expand their centralized school to meet the rise in school attendance. Wyckoff, the other community in Franklin Township, did not want to contribute financially toward a new school outside of its area, causing a great deal of tension. Taking a cue from surrounding municipalities that had taken advantage of a law that allowed boroughs to be formed by referendum vote, civic-minded citizens, led by William V. Pulis, worked to convince residents it was time to break away from Franklin Township. The Borough Act, passed in 1878, allowed landowners in an area under four square miles with less than 1,000 people to vote on leaving a township and forming a borough. Another provision of the law was that any seceding borough would have one consolidated school district, which suited the needs of the residents of Campgaw, Crystal Lake, and Franklin Lake nicely. A special election was held in February 1922 to incorporate Franklin Lakes as an independent borough, and the final vote came down to 185 for and 4 against. The population at that time was about 383 residents. Responding to the referendum vote, New Jersey Assembly Bill No. 430 was passed on March 11, 1922, incorporating Franklin Lakes as the newest borough in Bergen County.

In direct response to the formation of the Franklin Lakes Fire Department, Franklin Lake Borough Ordinances No. 7 and No. 8 were introduced in early 1925 to purchase a plot of land on Pulis Avenue for $300 and to build a firehouse there. The building would have a large room above it that hosted the council; later on, a small room was built that would host the police department. A closet in the basement was the original Department of Public Works. (Courtesy Susan Pulis.)

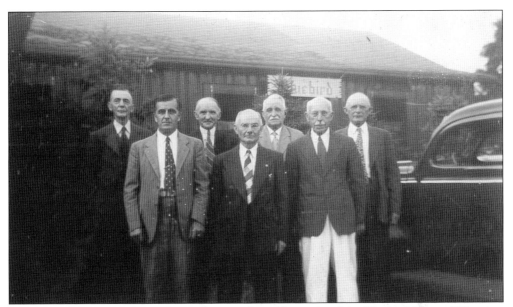

Members of the original 1922 borough council stand outside of the Bluebird Inn and Tearoom located on Franklin Avenue in this undated photograph. From left to right are (first row) Arnold Walder, Samuel Bowers, and George Scheck; (second row) Cornelius Bush, Fred Bender, William V. Pulis Sr., and Charles Fox. (Courtesy Mabel Ann Watkins.)

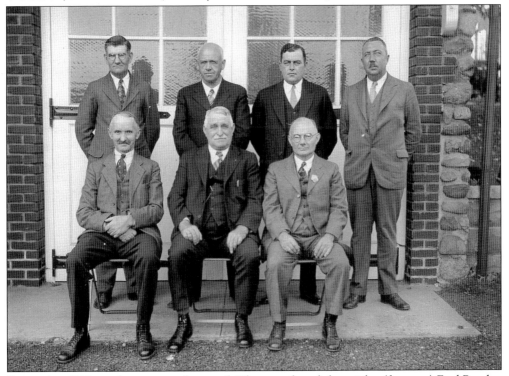

Pictured in 1931 are the mayor and council. They are, from left to right, (first row) Fred Bender, Mayor William V. Pulis Sr., and Samuel Bowers; (second row) George Peterson, William H. Ainlay, John B. Storms, and Edward C. May. (Courtesy Franklin Lakes Library.)

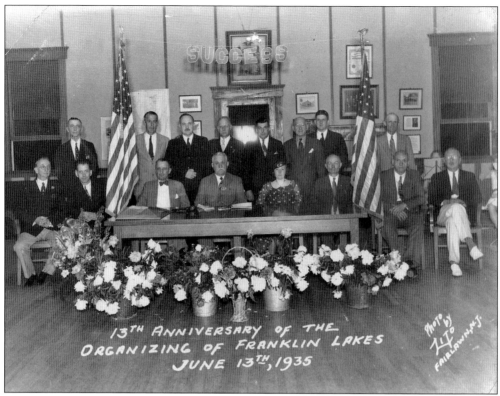

This photograph was taken in the original borough hall on the occasion of the 13th anniversary of the organizing of Franklin Lakes. (Courtesy Borough of Franklin Lakes.)

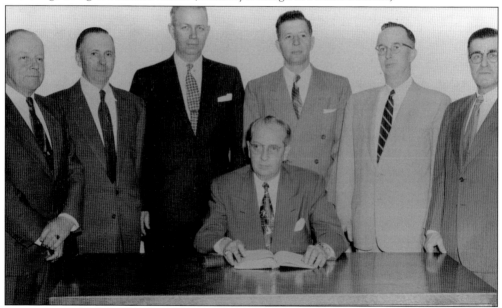

Pictured in 1953 are the mayor and council. They are, from left to right, (seated) Mayor John I. De Korte; (standing) A. Kimble, R. Bender, R. Cunningham, A.G. Sussex, R.C. Wilcox, and A. Alder. (Courtesy Borough of Franklin Lakes.)

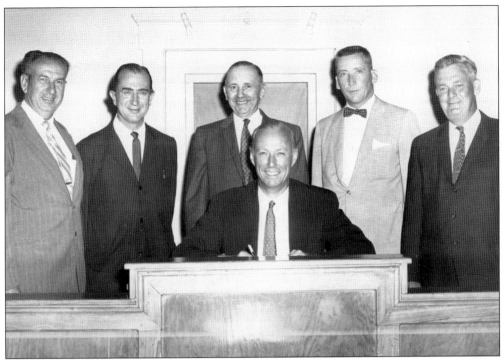

Pictured in 1960 are the mayor and council. They are, from left to right, (seated) Mayor Frank H. Hankins; (standing) J. Lauber Jr., C.E. Walker, R. Bender, J.F. Campbell, and R.G. Steves. (Courtesy Borough of Franklin Lakes.)

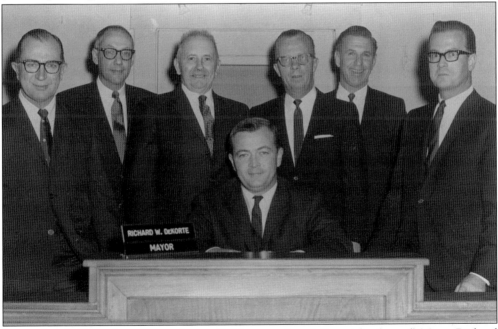

Pictured in 1967 are the mayor and council. They are, from left to right, (seated) Mayor Richard W. De Korte; (standing) C. Walker, A. Ward, R. Bender, G. Woods, R. Renné, and W. Kinney Jr. (Courtesy Borough of Franklin Lakes.)

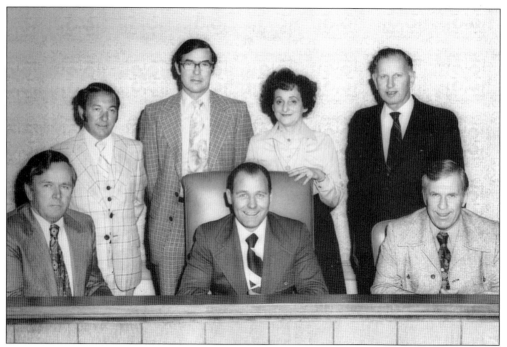

Pictured in 1976 are the mayor and council. They are, from left to right, (seated) H. Schlobohm, Mayor Thomas Pawelko, and R. Renné; (standing) W. Vichiconti, A. Keith, A. Ardia, and R. Krause. (Courtesy Borough of Franklin Lakes.)

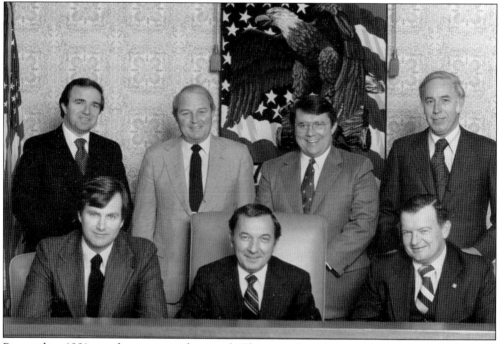

Pictured in 1981 are the mayor and council. They are, from left to right, (seated) William T. Smith, Mayor William Vichiconti, and Wayne P. Keene; (standing) Geoffrey Rosamund, Robert Brady, Thomas Donch, and C. Joseph Lillo. (Courtesy Borough of Franklin Lakes.)

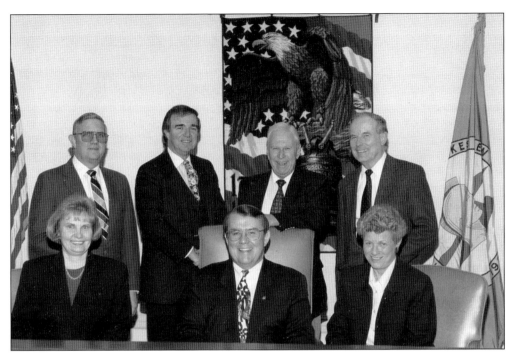

Pictured in 1995 are the mayor and council. They are, from left to right, (seated) L. Allen, Mayor G.T. Donch, and P. Ramsey; (standing) R. Schroeder, G. Rosamund, R. Renné, and R. Zwick. (Courtesy Borough of Franklin Lakes.)

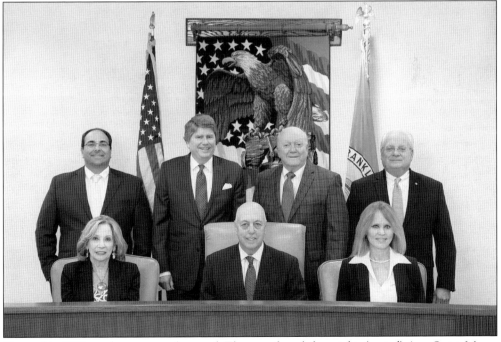

Pictured in 2022 are the mayor and council. They are, from left to right, (seated) Ann Swist, Mayor Frank Bivona, and Gail A. Kelly; (standing) Joseph Cadicina, Charles X. Kahwaty, Thomas G. Lambrix, and Dennis Bonagura. (Courtesy Borough of Franklin Lakes.)

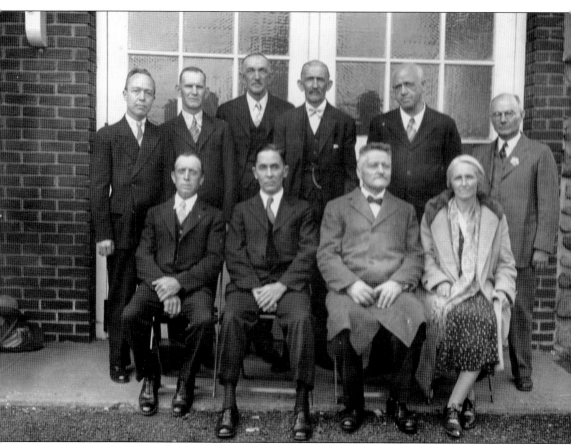

Members of the 1931 Franklin Lakes Board of Education are, from left to right, (first row) William Hill, Delbert Teeter, William DeBrat, and Madeline McKee; (second row) William Cosgrove, Abe Hopper, John Van Houten, Milton Burnish, William H. Ainley, and Samuel Bowers Sr. (Courtesy Franklin Lakes Library.)

Seven

First Responders

Not long after the incorporation of Franklin Lakes, 25 concerned individuals came together at the end of 1924 to create the Franklin Lakes Volunteer Fire Department. Since its inception, the fire department has been a key aspect of town and still benefits today from dedicated volunteers. A second firehouse was opened in 1974 on Franklin Lake Road in response to a rapidly growing population on Urban Farms properties. It sits directly across from the old cider mill, which would have benefited from a nearby firehouse when it was burned to the ground two years earlier.

In the early days, Franklin Lakes was served by marshals, residents who had the authority and power of police officers. Shortly after the borough was incorporated, this force was put together with August Bender serving as the first officer and, after 1926, serving under the title of chief marshal. In 1931, Bender received a salary of $300. In 1936, an official police department was created by ordinance with Chief Bender and police officers Charles Gorman and Hiram Meredith.

The Franklin Lakes Volunteer Ambulance Corps was formed in 1967 to meet the needs of the growing community and still dutifully serves today thanks to committed individuals with a desire to help those in need.

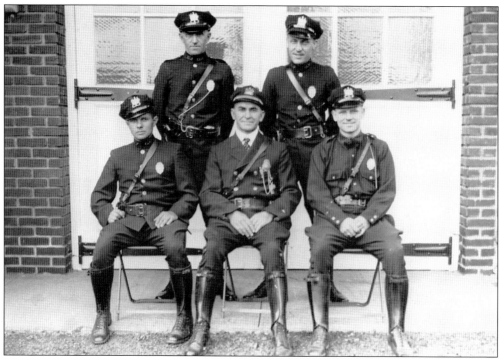

The first chief marshal appointed in 1922 was August Bender, seated here in the middle. Chief marshal Bender could appoint men to serve under him. This 1931 portrait shows, from left to right, (seated) Charles Bowers, Chief August Bender, and Hiram Meredith; (standing) August Bauer and Charles Gorman. (Courtesy Roger Ahl.)

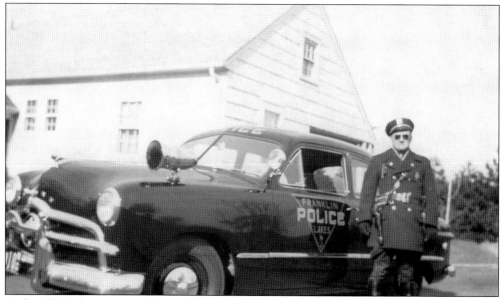

Arthur W. Pickering joined the police as a marshal in 1936, becoming the first full-time paid policeman 10 years later in 1946. He is pictured here with the first police car in 1949. He was appointed the first paid police chief in 1950. Chief Pickering retired in 1977 after 30 years with the force, having served 27 of them as chief. (Courtesy Roger Ahl.)

This 1950s traffic accident report photograph shows the Franklin Lake Road and Ewing Avenue intersection. This view is looking north on Ewing Avenue. Roehrs Nursery is on the left past the traffic light. (Courtesy Roger Ahl.)

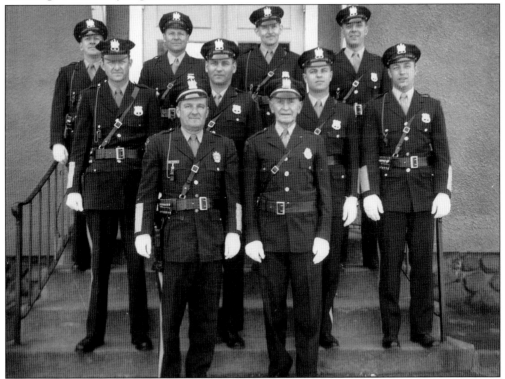

By 1961, the police department grew to 10 members. This picture was taken on the back steps of the old borough hall. Pictured up front are Chief Pickering (left) and the first appointed chief marshal August Bender (right). (Courtesy John Bockhorn.)

Pictured around 1967 is "the desk" at the recently built police headquarters on DeKorte Drive. (Courtesy John Bockhorn.)

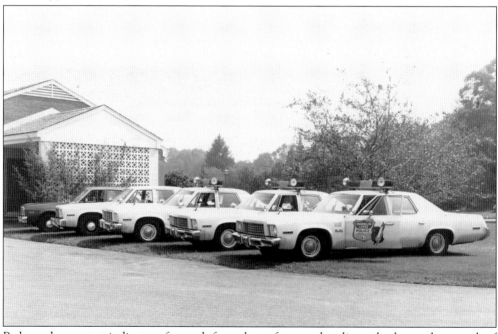
Perhaps the greatest indicator of growth from sleepy farms to bustling suburb was the growth of the police fleet. Taken in 1976, twenty-seven years after the first squad car was purchased for Art Pickering, three patrol cars, one undercover vehicle, and the chief's car make up the "modern fleet." (Courtesy Roger Ahl.)

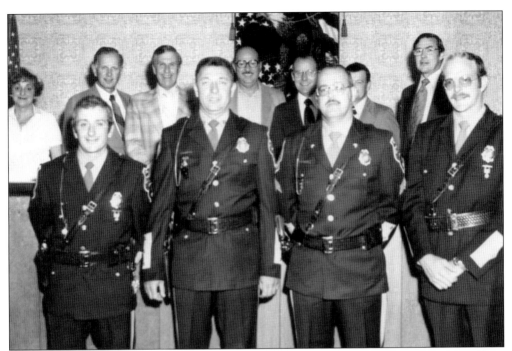

In June 1977, the Franklin Lakes Police Department reorganized its supervisory structure. From left to right with their promoted titles, Sgt. Robert Scanlon, Chief John Bockhorn, Lt. Brian Ahl, and Sgt. William Holland stand in front of the 1977 town council. (Courtesy Roger Ahl.)

Chief Pickering receives the flag that flew over Nike Missile Base NY-93/94C located off Pulis Avenue. The command unit was located in Franklin Lakes with the missile silos in Mahwah. Today, the Franklin Lakes portion of the Nike base is the Saddle Ridge Riding Center. Stables on the property are in converted base buildings. (Courtesy Jack Goudsward.)

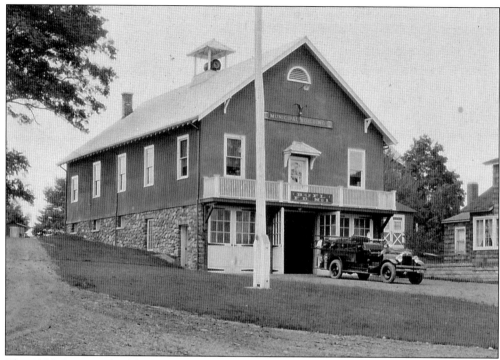

This 1926 photograph of the borough hall and fire department was taken shortly after the delivery of the 1926 Seagraves. (Courtesy Susan Pulis.)

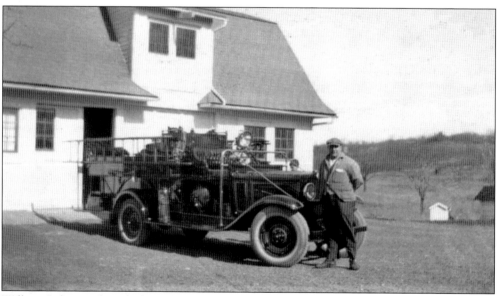

William Pulis stands with the 1929 Pope-Hartford truck outside of the H. Clark barn in Crystal Lake. There were rumblings at that time of opening a second firehouse near the Crystal Lake area. It is possible that the H. Clark barn served as a makeshift firehouse, but there are no records to support that. (Courtesy Franklin Lakes Fire Department.)

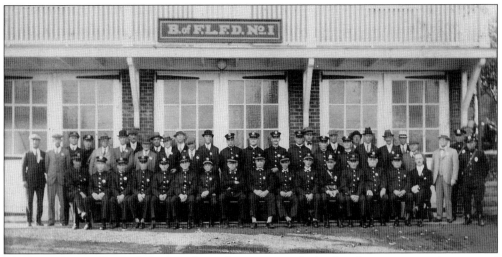

This 1931 group shot includes members of town council, the fire department, and appointed marshals. From left to right are (seated) D. Pruden, F. Gorman, G. Edwards, E. Clark, R. Bender, R. Bender, W.H. Hill, W.H. Ainlay, Chief W. Pulis, Assistant Chief Samuel Bowers, Assistant Chief C.J. Fox, C. Gorman, E. Voorhis, W.V. Pulis, J.B. Storms, and Rev. H. Bentley; (standing) unidentified, J. Sanders, chief marshal A. Bender, H. Meredith, H. Clark, H. McKee, J.R. Van Houten, A. Lozier, A. Perrin, W. Sisco, R. Vander Laan, J. Masker, C.H. Bush, K.W. Chilton, W. De Brot, F. Bender, J.A. Hopper, R. Romaine, D. Teter, A. Romaine, F. Gorman, E.C. May, S. Conklin, M.W. Burnish, N. Sisco, S. Bowers Sr., J.H. Badkin, S. Jackson, and unidentified. (Courtesy Franklin Lakes Library.)

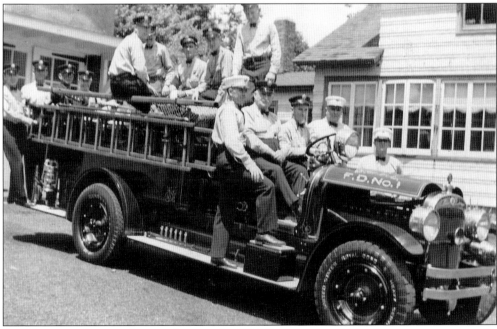

A 1939 group photograph was taken on the 1926 Seagraves truck. In the passenger seat is the first mayor, William V. Pulis; standing next to the driver is his son William Pulis, chief. (Courtesy Mabel Ann Watkins.)

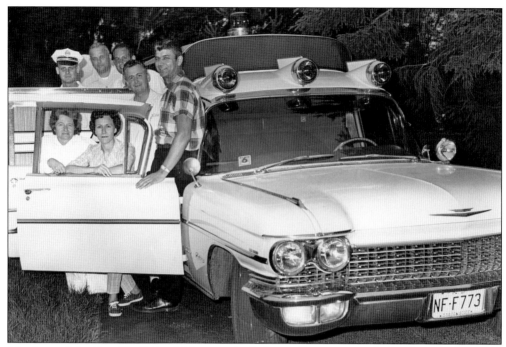

Members of the Franklin Lakes Volunteer Ambulance Corps pose with the first ambulance, a 1960 Cadillac, in 1967. Pictured are, from left to right, (first row) Joan Keene, corresponding secretary, and Judy Heller, recording secretary; (second row) Darry Emmett, captain; Warren Nelson, third lieutenant; Tony Diorio, second lieutenant; Bill Vermeulen, vice president; and Bill Tarulli, president. (Courtesy Franklin Lakes Ambulance Corps.)

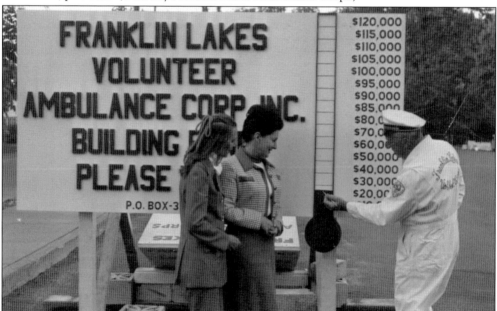

Jean Pawelko and Alice Renné watch on as Emmet Romaine updates the fundraising thermometer for a new ambulance corps building. Prior to this, the ambulance was kept in an open bay at the fire department building on Pulis Avenue. (Courtesy Franklin Lakes Ambulance Corps.)

Eight

SCHOOLS

Education has always been a pivotal aspect of life in Franklin Lakes and was the catalyst for the creation of the borough. Several schools have served the residents of Franklin Lakes going as far back as 1830. In those days, there were no school buses—children walked to school when the weather allowed and would miss classes when needed to help out on the family farm. In order to meet the educational needs of students who were expected to work at home, Sunday schools were created to educate children after going to church. Some of these schools were located in businesses, such as the Crystal Lake Depot. The Upper Campgaw School also had a special session on Sundays. Present research shows that as many as nine schoolhouses existed over the years before 1906, when the Campgaw School was built on the corner of Franklin Avenue and Pulis Avenue.

Students in the Crystal Lake part of town were educated on the first floor of the Voorhis home at the intersection of High Mountain Road and Summit Avenue until the house was sold; they then held classes in the old office space at the Federal Fiber Mill down High Mountain Road at the corner of Colonial Road. In 1903, a proper schoolhouse was built at present-day Terrace Road and was used for 20 years before all students were moved to the Campgaw School. The Crystal Lake School still stands today as a private residence.

Four schools serve kindergarten to eighth grade today. In 1931, a new schoolhouse was opened, with additions constructed in 1950, 1954, and 1969. Today, this is the Franklin Avenue Middle School. In 1962, High Mountain Road School was opened to alleviate overcrowding and was the first of three "neighborhood" schools built to serve various sections of town. Colonial Road School was completed in 1965. The final school, Woodside Avenue School, was opened in 1971 to meet the needs of a growing population in the northern half of town. Pupils originally went to high school in Paterson, then Ramsey, and, finally, Ramapo Regional High School, which was built on 40 acres straddling Franklin Lakes and Wyckoff, opening for students in 1956.

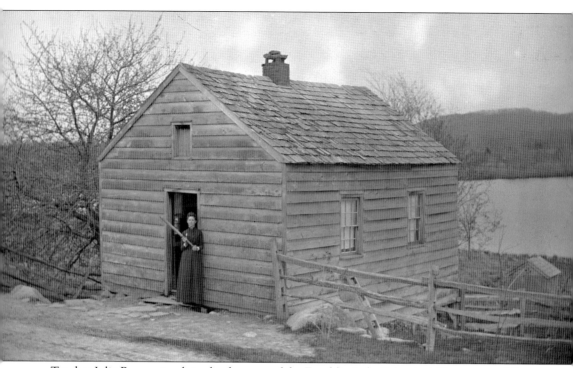

Teacher Julia Brown stands in the doorway of the Franklin Lake School wielding a very different "board of education." When the one-room building was torn down by J. MacKenzie in 1890, it was said to be the oldest schoolhouse in Bergen County. The building hung over a hill sloping down to Franklin Lake and was supported by posts in the rear. Coal for the stove was kept in the space below, and an outhouse was located not far behind. (Courtesy Franklin Lakes Library.)

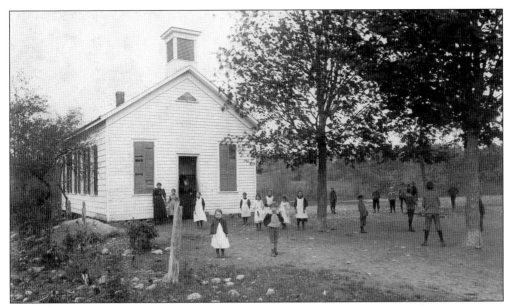

The Campgaw Western School, or School District No. 3, was originally located on the Peterson Farm at the corner of Franklin Avenue and Ewing Avenue. In April 1863, a meeting was held to elect trustees for the district. The building itself is believed to be older than this date, but this is the first time it appears in records. The school eventually moved closer to today's Bender Court, and in 1873, a new building was erected. Today, this building is a private residence on the corner of DeKorte Drive. (Courtesy Franklin Lakes Library.)

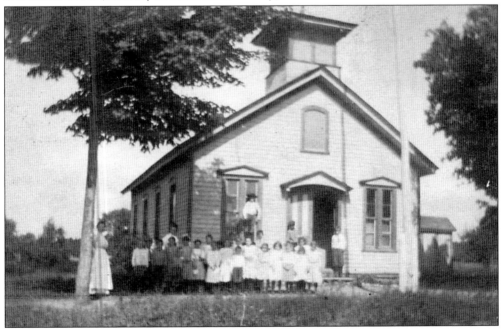

The Upper Campgaw School replaced a nearby stone structure in 1870. Before construction was complete, classes were held across the street in the William Ward house, where local children were taught by his daughters. The school was the first in town to be built by tax dollars. It stood until it was destroyed by fire at the end of the 1920s. (Courtesy Warren Storms.)

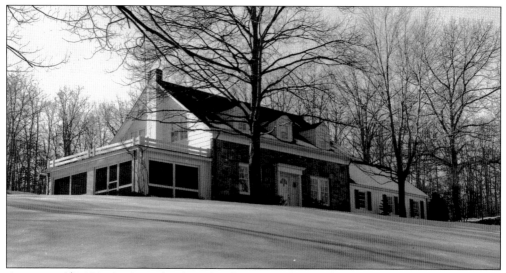

At a cost of $1,800, the Crystal Lake Schoolhouse was built in 1903 to alleviate overcrowding at the Campgaw Western School. From 1901, students in the area attended classes in rented rooms in a home at the corner of High Mountain Road and Summit Avenue. The house was sold shortly thereafter, and classes were held in the offices of the Federal Fiber Mill on the corner of High Mountain and Colonial Roads. Classes were held in the 1903 schoolhouse for 20 years before the borough sold it to the Crystal Lake Community Club, which operated it as a clubhouse. It is a private residence today on the corner of Terrace and High Mountain Roads. (Courtesy Mabel Ann Watkins.)

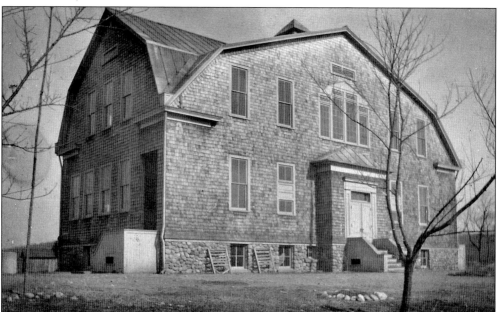

A four-room schoolhouse was built in 1906 in an attempt to grade the schools, anticipating a population boom. Built at a cost of $6,500, two rooms on the first floor were finished quickly and put to use. In 1908, the eighth grade was moved here from the Crystal Lake school. Students at this school recalled the shaky nature of the building and that there were a few instances on windy days when the structure was evacuated. (Courtesy Franklin Lakes Library.)

The first graduating class of the Campgaw School was 1909. From left to right are Edith Demarest, Emma Feldman, Jesse Pulis, principal Charles Behler, Mary Manwaring, Pearl Bush, and Sarah Bartholf. (Courtesy Franklin Lakes Library.)

This 1910 photograph shows all the students then currently attending the Campgaw School. Principal Behler sits on a stone cap on the main entrance stairs. (Courtesy Franklin Lakes Library.)

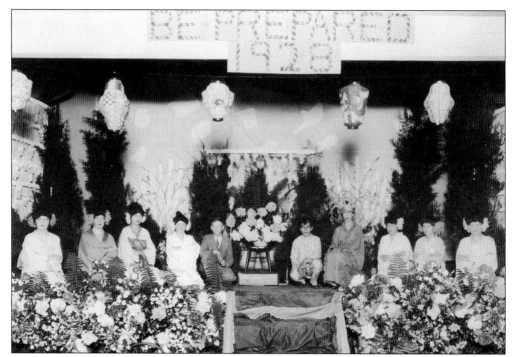

The graduation exercises of the 1928 Campgaw School class were held in the meeting room at the borough hall above the Pulis Avenue firehouse. The Campgaw School did not have an auditorium, and like other local groups, it used this space for large events. The names of the students are presently lost to time, but it is believed that the lady fourth from right is Elisabeth Storms. (Courtesy Warren Storms.)

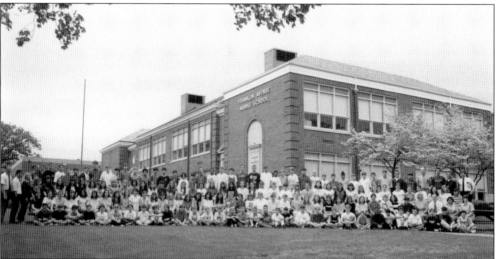

In 1931, a new eight-room schoolhouse was built adjacent to the 1906 Campgaw School. On the first floor were separate boys' and girls' gymnasiums at each end and an auditorium with stage in the middle. Upstairs were classrooms. This picture, taken in 1995, shows the 1931 school immediately behind the last class to graduate before a major renovation. The addition of more classrooms completely changed the exterior of the school, and it would be unrecognizable to the first students who attended Franklin Lakes School No. 1. (Courtesy Franklin Lakes Library.)

Opened just in time for the 1951 school year, the school added four new classrooms in anticipation of an enrollment of about 400 pupils over the next five years. The classrooms can be seen to the left of the original 1931 building. Additions in 1953 and 1969 reflected the population explosion of school-age children as Franklin Lakes became more suburban. (Courtesy Franklin Lakes Library.)

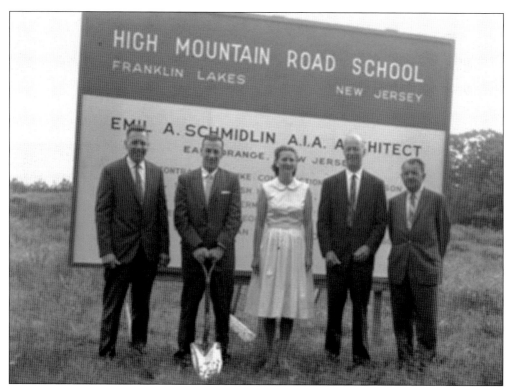

By the early 1960s, Franklin Lakes found itself needing more classrooms. Discussions had long been held about building a school somewhere in the southern part of town on the former J. MacKenzie property. When McBride acquired the estate's landholdings, he donated a site on High Mountain Road to the town. Ground was broken on August 12, 1961, using the same shovel from the groundbreaking ceremony of the 1931 schoolhouse. From left to right are principal J. Manz, board of education president R. Belscher, home and school association president M. Bosshard, Mayor Frank Hankins, and architect E. Schmidlin. (Courtesy Franklin Lakes Library.)

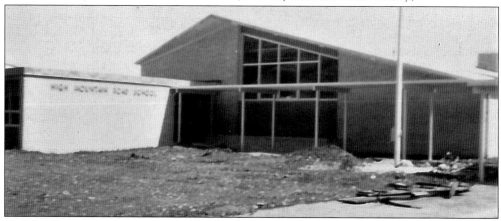

The High Mountain Road School opened in September 1962 and taught students from kindergarten to sixth grade, with the Franklin Avenue school converted into a junior high school serving seventh and eighth grades. The new school would have 16 classrooms, with 2 of them dedicated for kindergarten classes. The maximum number of students the school would be able to accommodate would be 520. (Courtesy Susan Pulis.)

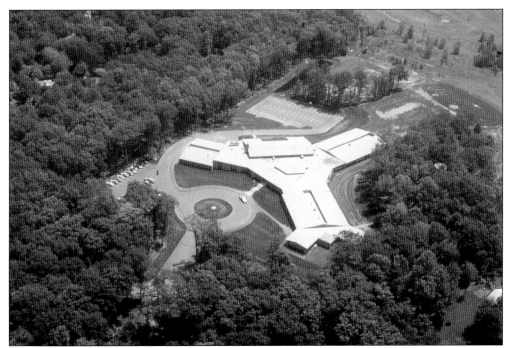

The Colonial Road School opened on the west side of town in 1965. The land was acquired in 1964 from the estates of John McKenzie and Herbert Clark, in addition to a parcel from the Borthwick family. The new school had the ability to accommodate 520 students. (Courtesy Franklin Lakes Public Schools.)

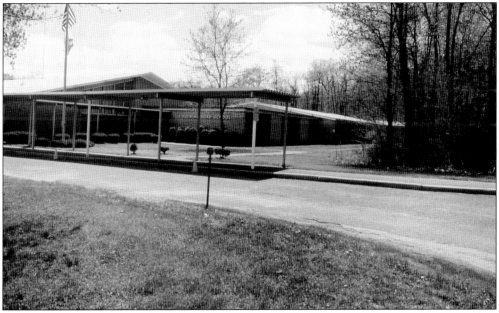

Almost 10 years after the first elementary school opened, Woodside Avenue School was completed in the northern part of town, serving the fast-growing Shadow Lakes development. With a different layout than the previous two schools, Woodside has a decidedly 1970s feel. (Courtesy Franklin Lakes Public Schools.)

Discover Thousands of Local History Books Featuring Millions of Vintage Images

Arcadia Publishing, the leading local history publisher in the United States, is committed to making history accessible and meaningful through publishing books that celebrate and preserve the heritage of America's people and places.

Find more books like this at
www.arcadiapublishing.com

Search for your hometown history, your old stomping grounds, and even your favorite sports team.

Consistent with our mission to preserve history on a local level, this book was printed in South Carolina on American-made paper and manufactured entirely in the United States. Products carrying the accredited Forest Stewardship Council (FSC) label are printed on 100 percent FSC-certified paper.